Bob Durham

How to Paint
Seascapes
in Watercolor

How to Paint Seascapes in Watercolor

BY E. JOHN ROBINSON

WATSON-GUPTILL PUBLICATIONS/NEW YORK

First published 1981 in the United States and Canada by Watson-Guptill Publications,
a division of Billboard Publications, Inc.,
1515 Broadway, New York, N.Y. 10036

Library of Congress Cataloging in Publication Data
Robinson, E. John, 1932–
 How to paint seascapes in watercolor.
 Bibliography: p.
 Includes index.
 1. Marine painting—Technique. 2. Water-color
painting—Technique. I. Title.
ND2270.R6 751.42'2437 81-19808
ISBN 0-8230-2466-0 AARC2

Manufactured in Japan

First published 1982 in New York by Watson-Guptill Publications,

1 2 3 4 5 6 7 8 9/86 85 84 83 82

*To James Edward Peck,
whose teachings live on
through his students.*

Acknowledgments
To Dot Spencer, Bonnie Silverstein,
Bob Fillie, and the rest of the staff of
Watson-Guptill Publications, a warm
"thank you" for encouraging me to
write another book and then having
the patience to see me through it.

Contents

Introduction 10

PART 1. BASIC INFORMATION 15
1. Watercolor Materials and Equipment 16
2. Composition 22
3. Color 36
4. Basic Seascape Elements 40
 Waves 41
 Rocks and Headlands 50
 Skies and Clouds 61
 Beaches 68

PART 2. PUTTING IT ALL TOGETHER 77
1. **New England Coastline 78**
 Painting Breaker Foam 79
 Painting a Collapsed Wave 81
 Color Demonstration 83
2. **Storm Water 86**
 Painting Wave Patterns 87
 Using Patterns for Direction 88
 Compositional Sketches 90
 Color Demonstration 91
3. **Tropical Waters 96**
 Painting Rock Spills 98
 Painting a Foam Burst 100
 Painting Palm Trees 97
 Color Demonstration 102
4. **California Sunset 106**
 Painting Glow 107
 Compositional Sketches 109
 Color Demonstration 110
5. **An Oregon Beach 114**
 Composing a Beach Scene 115
 Compositional Sketches 122
 Color Sketch 123
 Color Demonstration 124

PART 3. TIPS AND COMMENTS 129
1. **Finding a Subject 130**
2. **A Final Word 136**

Bibliography 141
Index 142

Introduction

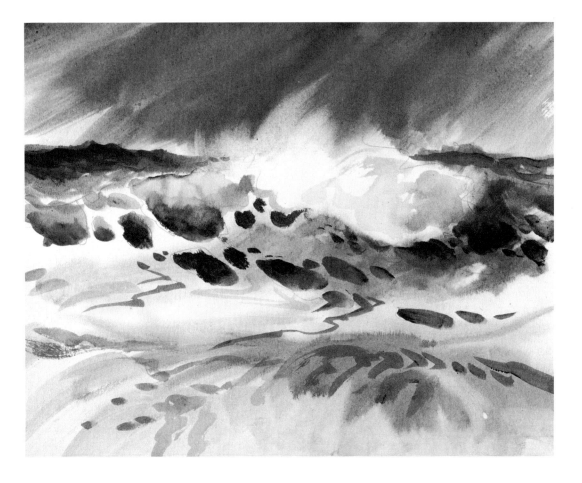

Not many people are aware that I paint the sea in watercolor as well as in oil, since my first three books—*Marine Painting in Oil, The Seascape Painter's Problem Book* and *Master Class in Seascape Painting*—all dealt with painting the sea in oil. In the last book, however, I introduced a watercolor I had done as a preliminary sketch. That watercolor sketch initiated the interest that eventually led to writing this book. You may rest assured, however, that in this book watercolor will not be treated as a sketching medium, but as a very sophisticated and challenging method of painting the sea.

Long ago, I learned to take painting seriously no matter what medium was used. My first watercolor instructor was James Edward Peck of Seattle and much of what he imparted to me will be carried on to you.

Peck had endless patience and a great deal of savvy regarding young students. He understood our eagerness to get started and chuckled as we impatiently applied paint to paper. Later he would come by and console us for our frustrating results. Yet we ourselves were never able to be patient, but approached every new painting with a youthful, raw eagerness.

Eventually, when we were more inclined to pay attention, Peck would lead us through some preliminaries. If we were to paint a building, he would encourage us to look at it from all angles, to touch it, and, if possible, to enter it. In short, he encouraged us to get to know each subject thoroughly. One time he even had us roll through tall, spring grass to understand the feel of what we were about to paint.

Peck would often paint a demon-stration for us. Before he began, he would always make a few preliminary sketches—small, thumbnail-sized scribbles of lines and values. Then when he had his "recipe" he would proceed and we marvelled at his orderly procedure, and his fresh, clean paintings.

Eventually we learned that we could avoid a lot of mistakes if we took the time to work out what we wanted, by first creating a guideline to give us direction, yet one flexible enough to change, if necessary, as we worked. And it is this approach that I wish to impart to you in this book. I will therefore show you step-by-step how I work up a composition and follow it through to a final painting. I will also teach you the anatomy of the sea—the swells, breakers, foam, foam bursts and foam patterns. And I will show you methods for painting rocks, headlands, skies, beaches, and

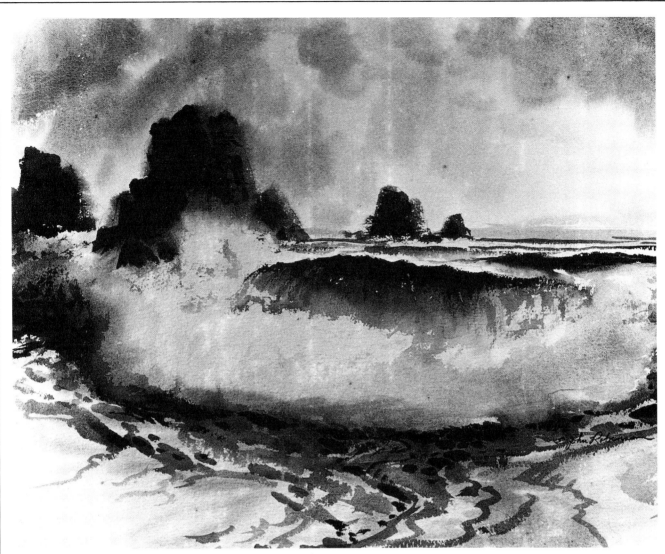

Oregon Rocks, 16″ x 20″ (41 x 51 cm), Arches 300-lb rough paper.

In this painting, the breaker is the main
attraction and so I have textured the
foreground to lead the eye to it. Since the
sunlight is high and is focused on the
background, more of the vertical sides of
the rocks are in shadow and the rocks do
not have light tops.

Wave Study, 17″ x 22″ (43 x 56 cm), Arches 300-lb rough paper.

This is an example of a quick on-location sketch. It is not one of my best sketches, but it does contain the information I wanted from the location.

I worked on a wet paper with a no. 12 round sable brush. After placing a few brief pencil lines on the paper to show the location of the major areas, I painted the sky and foreground shadows. Then, as the paper began to dry, I painted the darkest portions of the wave. Finally, when the paper was dry, I painted the foam holes and added a few directional lines. The entire sketch took less than thirty minutes.

many of the incidental details they include. In addition, I will teach you a bit about my theory of composition and color and, of course, how I make a thumbnail sketch.

I also demonstrate how to paint five typical coastal scenes, each involving a different area of the nation, with its own individual characteristics. This gives me the opportunity to show you how to paint specific local seascape elements. For example, in painting an Oregon beach, I also teach you about the characteristics of sand. Painting the New England coast, I emphasize a breaker and a collapsed wave. Painting storm waters, I discuss the need for a strong composition in painting a big, moving sea. Painting an active sea also gives us a chance to study foam patterns. Then I paint a tropical coastline. Tropical waters can also be stormy, but here I emphasize foam bursts and water spilling from dark lava rocks. Finally, painting the Big Sur area in California, I show how to paint the warm glow of sunset and how to match the brilliant sky to a suitable composition.

Since *How to Paint Watercolor Seacapes* is designed to serve a wide range of student needs, it contains both basic material on the sea and on painting technique as well as advanced work. If painting the sea is a relatively new experience for you, I must encourage you to be patient if you do not immediately get the results you want. If you are not certain of basic knowledge, please take the time to work out the step-by-step demonstrations before going on to a final painting. Success takes time, but frustration is always readily available.

If, because of your enthusiasm, you find yourself rushing into a painting, pause a moment—and perhaps you will hear my teacher's now-distant chuckle. Spend a quiet moment contemplating your subject instead and you may avoid less tranquil moments later.

Also keep in mind that my approach is only one of many ways to paint the sea and should not be considered sacred. Explore other approaches, then decide for yourself which one you want. All I ask is that you give these lessons a chance. They are tools to be picked up when the need is there.

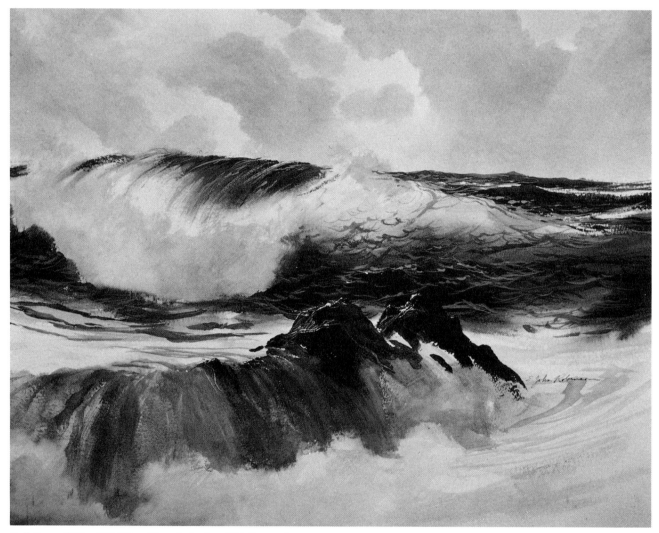

Full Force, 22″ x 30″ (56 x 76 cm), Arches 300-lb rough paper.

This is a painting of a large wave supported by a rock and the remains of a former wave. I used a full sheet for this painting because I wanted to work large with a large subject.

I started by underpainting the wave with Hooker's green on wet paper. The sky was painted at the same time using ultramarine blue. When the paper was semi-dry, I painted a second set of clouds over the blue sky. I used ultramarine blue and yellow ochre. I used the same mix to shadow the wave foam and foreground water but with more blue.

When the paper was dry, I added the textures and reflected lights. I departed from the traditional transparent watercolor technique when I overlaid reflected lights on the wave face. For this I used a tiny No. 000 round sable brush and cerulean blue straight from the tube. The effect is opaque, but I make no apologies for this departure from traditional transparent technique because I have achieved an effect nearly impossible to achieve by any other method.

Part One

BASIC INFORMATION

Materials and Equipment

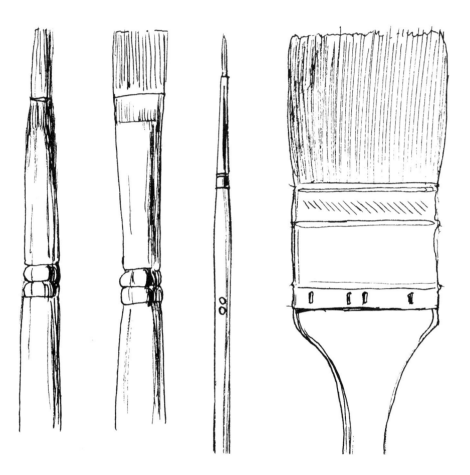

During my many years of painting, I have experimented with a variety of materials and equipment and have gradually come to hold a special few as important to my painting comfort. I will describe them to you now since you may want to try some of my favorites. Perhaps you will find them comfortable, too.

Paper

I prefer to use a 300-lb rough paper by Arches for most of my studio work. I buy the 22″x30″ (56 x 76 cm) size and cut smaller pieces as I need them. This paper has plenty of "tooth" to grab the paint from the brush, yet the texture is not mechani-

cal. The paper is also heavy enough not to wrinkle while wet.

Sometimes I use an Arches-brand watercolor board. This is a medium-weight 90-lb paper mounted to a rigid board, also 22″x30″ (56 x 76 cm). Occasionally I use a 250-lb, 100 percent rag paper made by Watchung. Although the paper has a beautiful random texture, it isn't quite as rigid as 300-lb paper. Since paper that is lighter in weight than this usually needs to be stretched over a frame or on a board, which is a nuisance to me, I seldom use it.

For outdoor work I may use a good paper tacked to a board, but more often I work on a watercolor

block. Arches puts out one called "Movlin à Papier d'Arches." The blocks range in size from 9″ x 12″ (23 x 30 cm) to 18″ x 24″ (46 x 61 cm). Each block contains twenty-five sheets of 140-lb rough or cold-press (medium rough) paper. The price is not that much higher than good sheet paper and blocks offer the convenience of a clean sheet ready for use just under the one you are now using.

Paints

There are several good brands of watercolor paint on the market, so rather than recommend one, I would prefer that you select your own

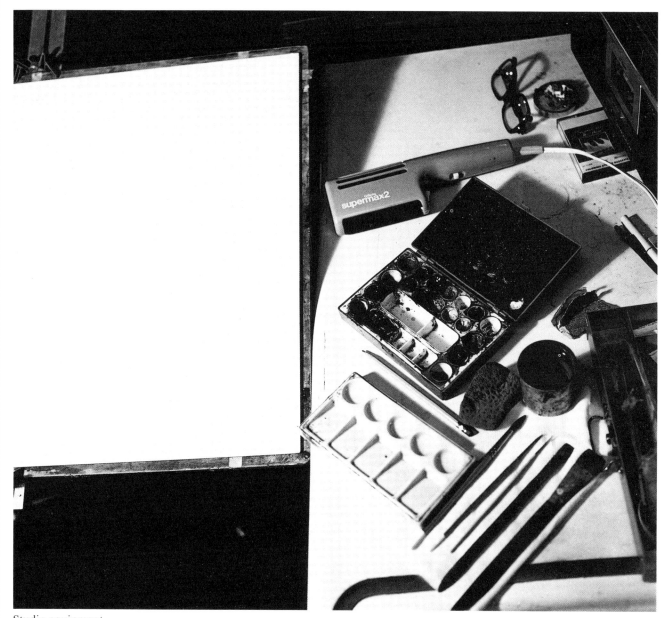

Studio equipment.

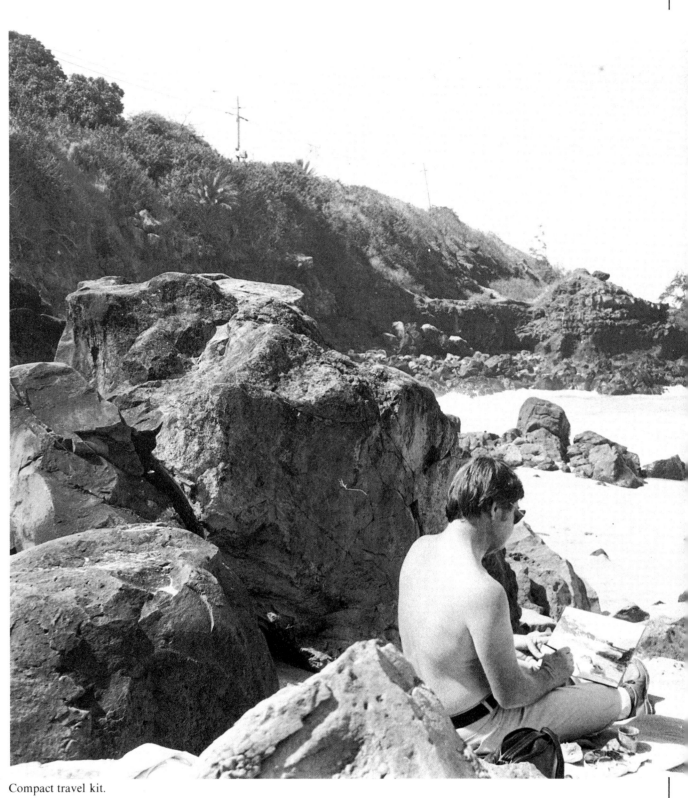

Compact travel kit.

brand. In fact, I use at least three different brands myself. Simply ask your dealer for paint of the best quality. It doesn't cost that much more to have quality paint and it will give you the security of knowing your colors will stay permanently bright and won't disintegrate the paper either.

Palette

I have a rather limited palette, which I reduce even further for individual paintings. Here is my general selection of colors:

Red
Alizarin crimson
Cobalt violet

Yellow
Cadmium yellow light
Cadmium yellow medium
Cadmium orange

Blue
Cobalt blue
Ultramarine blue
Manganese blue
Cerulean blue

Green
Hooker's green light
Hooker's green deep
Sap green
Viridian

Earth Colors
Yellow ochre
Raw sienna
Burnt sienna
Burnt umber

Chinese White

I rarely use white, but I am not so much of a purist that I avoid it altogether. Occasionally it is just perfect to tint another color. What I do avoid, however, is using white by itself or as a glaze over other colors. That would make my watercolors opaque rather than transparent.

I also avoid the phthalo colors. I find them too powerful and too unlike the colors of the sea, unless they are blended with other colors, including white.

Brushes

I have few brushes, but the ones I own are top quality. When I flip the water out of one of my round sables, I expect it to produce a fine point—and I have a brush or two that can still achieve that after several years' use.

For wetting the paper, expensive brushes are unnecessary. I like a 2″ (5 cm) flat bristle varnish brush. But I don't care for camel hair brushes because the hairs are too soft for working over rough-textured papers.

My other brushes are all pure red sable, the finest I can buy. They don't leave hairs behind them on the paper and they produce a point when I need it. When I need flat brushes, I use Aquarelles (made by Grumbacher). I have one that is ½″ (13 mm) and another that is 1″ (25 mm). Either one can be used for washes or specific painting needs. My round sables are Nos. 00, 2, 4, 6, 10, and 12. In most cases I only use two or three at a time, but sometimes I require a particular size for a special area. Only you can decide that as you paint.

Paint Box

Grumbacher makes a dandy covered paint box. There is a piece of plastic in the lid that absorbs water and keeps the paints moist. But it is a bit small. Someday I will have to invent a larger one that also has a good mixing area but until then, I also carry a mixing tray. Again, I like something small. The tray I use is made of porcelain, but you may find a tin tray just as convenient. This is one piece of equipment I always keep clean.

I also use a small elephant-ear sponge for wetting the paper and for lifting color as I paint. I have a small one for travel and a large one for the studio. I store it in my water pot, which is simply a tin can. Besides these items, I also have a box of T-pins, a roll of paper towels, a sharp-pointed knife, a pencil and sketchbook for thumbnail sketches, and a sheet of sandpaper for lifting off color after the paper has dried.

Additional Studio Equipment

For indoor painting, I use all the before mentioned materials plus a stand-up tripod easel and a hair dryer. As you may see in the photograph on this page, I have set my board and paper on an easel. Because I am right-handed, I have set up my tools on the right. The brushes are laid on folds of paper towels. The mixing tray, sponge, and can of water are placed just below the open watercolor box. Everything is within easy reach. The hair dryer is plugged

in next to my radio-cassette player. Now all I need is a painting idea and the urge to paint!

Compact Travel Kit

If I travel anywhere too distant to lug all my gear, I make up a special kit. This is especially advantageous when traveling by air.

As you can see in this photograph of me on Waimea Beach in Oahu, Hawaii, I have traveled so light that I've even left my shirt behind! I am carrying a small camera case with no more than a dozen tubes of paint, my covered paint box, a small mixing tray, a sponge, four brushes (a ½″ flat Aquarelle and Nos. 00, 4, 6, and 10 round sables), a tin for water (fresh water is usually available nearby), and a 9″x12″ (23 x 30 cm) watercolor block. I am sitting on a bamboo mat.

Traveling this light, I have been able to paint all over the world, bringing home quick sketches that can be transformed into finished paintings in the studio at a later time.

Regular Outdoor Kit

My outdoor kit differs only slightly from my compact travel kit. I still carry the covered paint box, small mixing tray, tin for water, small sponge, and a few brushes. But in addition, I have a small tackle box to hold my paint tubes, pencil, brushes, and paper towels.

I also carry a large, folding stool that has a canvas seat with large storage pockets below. Most of the above-mentioned items, plus a jug of water, fit into the pockets.

In the photograph at left I have chosen an 18″ x 24″ (46 x 61 cm) watercolor block and a drawing board of the same size. The drawing board has a fold-up rod that supports it in an upright position. This setup allows me to carry everything I need in two hands as I hike over headlands.

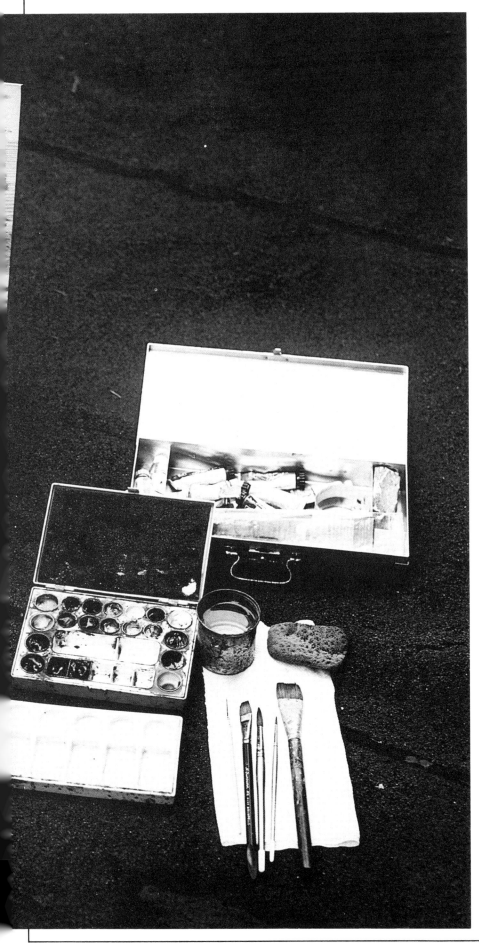

Outdoor painting materials.

21

Composition

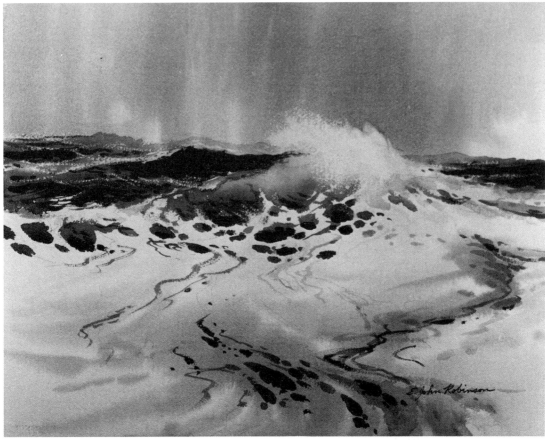

Foamy Surf, 18″ x 24″ (46 x 61 cm), Arches 300-lb rough paper.

Artists have long been trying to bring something more than just a "snapshot" view of nature to their paintings. They not only try to paint what they see, but also what they feel. Moreover, they try to convey their message so that the viewer is aroused in the same way. This doesn't mean that they try to make everyone feel good. On the contrary, some artists try to make their viewers feel all moods, good and bad. Sometimes the underlying theme is so subtle that not everyone will respond to it. But then again, all art is not for all people.

The study of art and the interaction with it experienced by the viewer is called "aesthetics." I cannot devote much space to this compli-cated subject, but I can give you some basics on composition and color that will help you avoid disharmony and poor aesthetics.

My first point about composition—one we have already discussed—is to compose with an understanding of the subject. My second suggestion is to compose with feeling. Artists—even beginners—can't help but convey their own personal feelings in their paintings, but knowing a bit about composition will make it much easier to express those feelings.

Composition may also be called "arrangement." Composing a painting means arranging (or re-arranging) objects and areas of space to better convey a message. I believe that civilized man still prefers harmony over chaos, no matter how much garbage we see around us every day. There is great beauty in simplicity and clear-cut truth still commands attention. This is why good composition is so essential.

The following pages are devoted to simple compositional truths: understanding the difference between line and outline, focusing on a center of interest, understanding areas of composition, composing with three basic values, and putting these values to work in a thumbnail sketch. With this basic knowlege, you will be able to compose more easily and bring harmony to your paintings and more. You will then be able to express your feelings as well as record the sea.

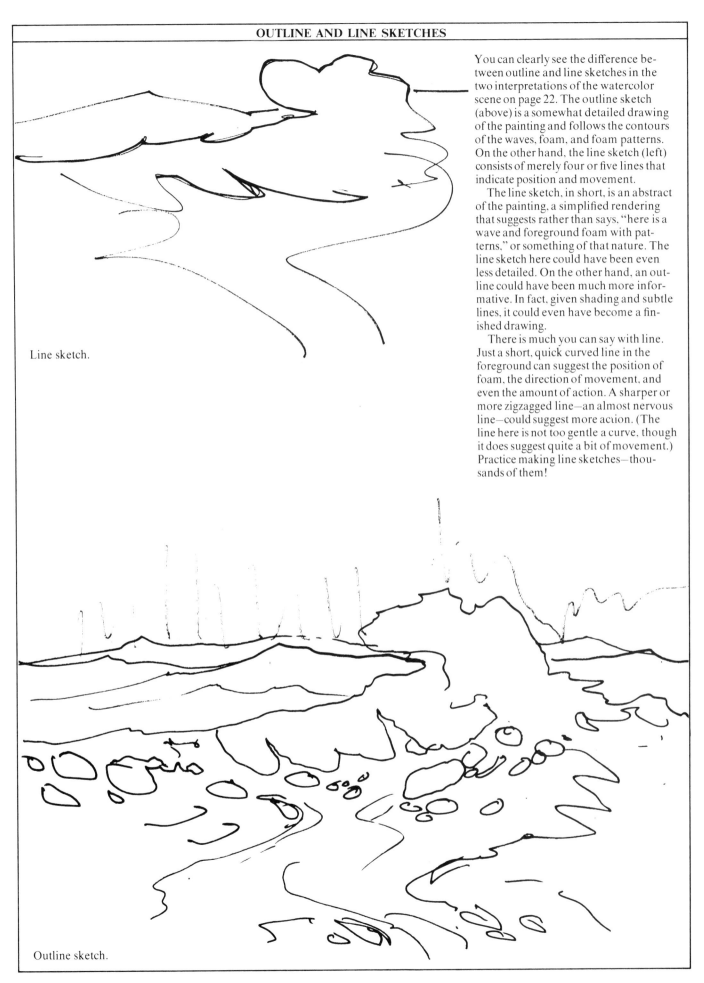

You can clearly see the difference between outline and line sketches in the two interpretations of the watercolor scene on page 22. The outline sketch (above) is a somewhat detailed drawing of the painting and follows the contours of the waves, foam, and foam patterns. On the other hand, the line sketch (left) consists of merely four or five lines that indicate position and movement.

The line sketch, in short, is an abstract of the painting, a simplified rendering that suggests rather than says, "here is a wave and foreground foam with patterns," or something of that nature. The line sketch here could have been even less detailed. On the other hand, an outline could have been much more informative. In fact, given shading and subtle lines, it could even have become a finished drawing.

There is much you can say with line. Just a short, quick curved line in the foreground can suggest the position of foam, the direction of movement, and even the amount of action. A sharper or more zigzagged line—an almost nervous line—could suggest more action. (The line here is not too gentle a curve, though it does suggest quite a bit of movement.) Practice making line sketches—thousands of them!

Line sketch.

Outline sketch.

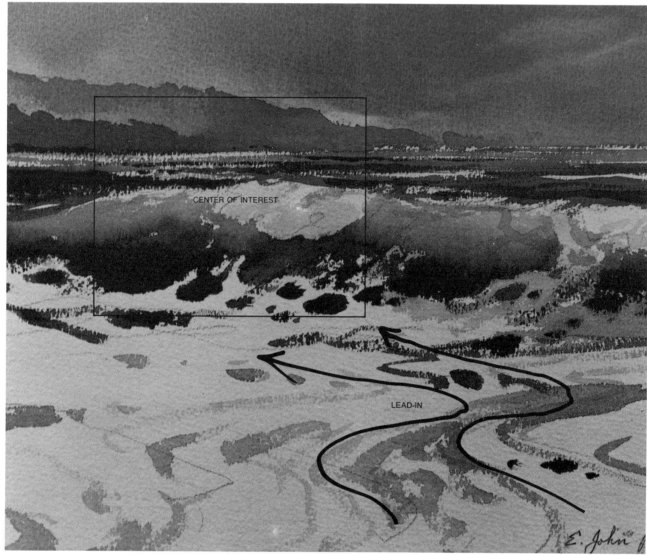

CENTER OF INTEREST

LEAD-IN

Lead-ins need not be obvious. In this painting I have used two sets of foreground lines to lead the eye to the center of interest. The first set begins the movement but then veers to the right. But the dark foam holes intercept the retreating line and provide stepping stones back to the focal point.

You can create lead-ins with a series of rocks, of minor waves, foam patterns, or even colors. The main point is to use them, but do it subtly. Remember, you can control the mood of your painting by the speed at which the eye is led to the focal point and by the quality of its path, whether gentle or rough. But let the mood of the scene determine just how you approach it.

A word about the center of interest,

the reward at the end of the trail. The center of interest should command more attention than any other part of the composition and should not have to fight with something else for that position. But don't be afraid to include other interesting things in the painting. Just remember to keep them secondary.

One way to increase attention is to keep the lightest light and the darkest dark at the focal point. Another way is to give more detail to that area. Still another way is to place commanding color at the focal point, one slightly different or outstanding compared to the rest of the composition. Again, you must choose your own personal way to best express what you feel about the subject.

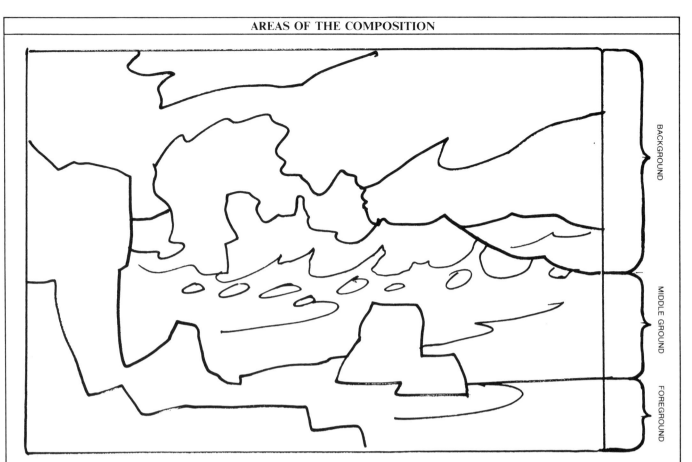

BACKGROUND

MIDDLE GROUND

FOREGROUND

For purposes of simplification, I like to divide my compositions into three areas: background, middle ground, and foreground. As in this illustration, each area should be different in shape and size.

Notice that while all three areas meet on the right edge of the paper, only the background and foreground are on the left. Also, none of the boundaries between the three areas forms a straight line across the page and each area has its own distinctive shape. These are important facts for composing a seascape without repetition and without clutter.

A composition also can be divided in other ways. The boundary lines could be vertical instead of horizontal, for example. And instead of having three areas—background, middle ground, and foreground—you can have two or even one, although it might be difficult to create a single area of interest without its seeming too obvious.

On the following pages you will see that by combining three areas with three values you will get six distinct value arrangements for each linear composition.

AREA OF INTEREST

AREA OF INTEREST

Using the preceding drawing as our linear composition, let's examine how the center of interest in the following value sketches varies with the arrangement of lights, darks, and middle values. First let's examine a composition where the middle area is light in value. As you can see, the upper arrangement here consists of a middle value in the background and a dark value in the foreground. The area of interest, which always falls to the spot where the contrast is greatest, goes to the middle and foreground.

In the lower example, on the other hand, the values of background and foreground are reversed. So now the eye tends to be drawn upward to the background and middle ground area where the contrast is greatest.

Remember when composing that the area with the strongest contrast—the lightest light next to the darkest dark—will command the most attention. So you can shift the center of interest of any of the arrangements here by simply toning down all other contrasting areas except where you want the viewer to look.

AREA OF INTEREST

AREA OF INTEREST

Strange things happen when a middle value is in the area of interest. In both of these examples, the area of greatest contrast is where the background meets the foreground; the middle ground is somewhat lost.

The reason for this shift of interest from the center area to the side is that the eye always heads for the area with the greatest contrast. And while there is a full step between the light and dark areas on the side, there is only half a step between the light and middle values and between the dark and middle values.

If you want the area of interest to be elsewhere, you can create a full-step contrast in that other spot and soften the contrast in the first area by putting a middle-value area between the extreme light and darks. You can also pull interest away from that area by introducing a bright color into another area and by adding more detail somewhere else. But if you decide to change the center of interest, don't forget to reduce the contrast in the old area of interest so it won't detract from your new focal point.

AREA OF INTEREST

AREA OF INTEREST

When the area of interest is dark, as in the compositional sketches here, we once again have a full step between it and one of the adjacent areas. In the top example, where the background is middle value and the foreground is light, the greatest contrast is between the middle ground and the foreground. But in the lower figure, your eye is drawn to the dark middle ground and the light background. It also takes in a bit of middle value. Thus, an area that contains all three values can also draw attention.

Now that you have seen the six major possibilities in placing the three basic values in three main areas of a composition, you should practice using them. Of course, hundreds of other variations are possible, and there are certainly more than three values. But it is my contention that you will develop the other more subtle values automatically as you paint—and I feel that composing with more than three values is confusing.

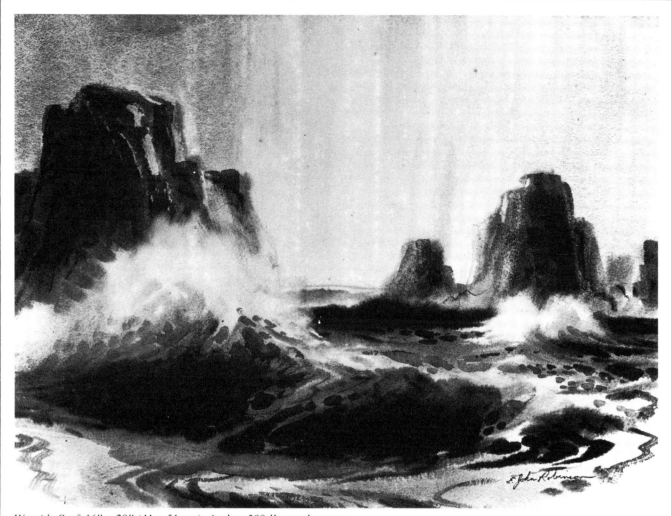

Wayside Surf, 16″ x 20″ (41 x 51 cm), Arches 300-lb rough paper.

In this southern Oregon scene—the same area as *Oregon Rocks* (page 11)—I have used the effects of downlighting to high- light the rock and surf. I began by paint- ing the sky on wet paper with a 1″ flat sable brush to make vertical strokes. I started with the darkest value on the outer edges and worked toward the cen- ter. Since the paint was diluted with each stroke, it therefore lightened as I worked. I also tilted the board so the colors would run down. Next, I painted the base colors of the rocks and sea. After the paper dried, I added the texture and lines. No- tice that the vertical face of the rocks and waves are dark, while the tops and sides facing the sunlight are light.

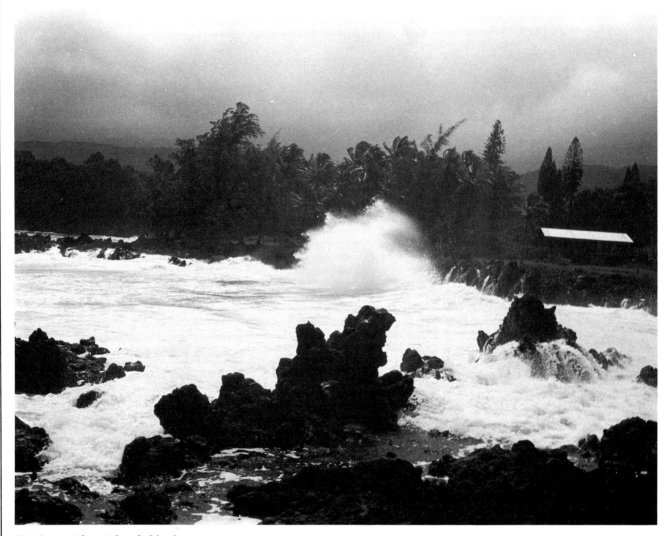

The Scene (above). I took this photo one stormy day on the island of Maui in the Hawaiian islands. The area of interest is easy to spot, with the action taking place where the contrast is greatest— where the light foam bursts against the dark foreground rock (or to rephrase it, where the dark foreground rock is outlined against the white foam burst). The photograph and the values could have been rearranged in other combinations, but I chose this arrangement because I felt it was a natural one for the subject. The foam burst was so demanding that it had to be the focal point. Therefore all the other values had to enhance that one.

Had you been there, you might have seen it differently. But, of course, that is what real art is all about! Art is not just a reasonable imitation of nature. It is an expression by an individual. Each of us are different and each of us will tell the story the way we like to hear it.

Line Sketch (top right). The composition of the photograph is nearly perfect as it stands, but it does need some refinement to make it read better. To refine it, I first drew a quick line sketch that clearly divides background, foreground, and middle ground.

Value Sketch (right). I decided to keep the values pretty much as they were in the photograph, but I did want to increase their support to the center of interest. So I lightened the background area of trees, which put the whole background into a group of middle values that read as one large middle value. This reduced the distracting contrast at the left of the foam burst. Finally, I toned down the light foam at the left of the picture so the remaining foam was limited to a smaller area. (The center of interest must be smaller than other areas or it will become lost.)

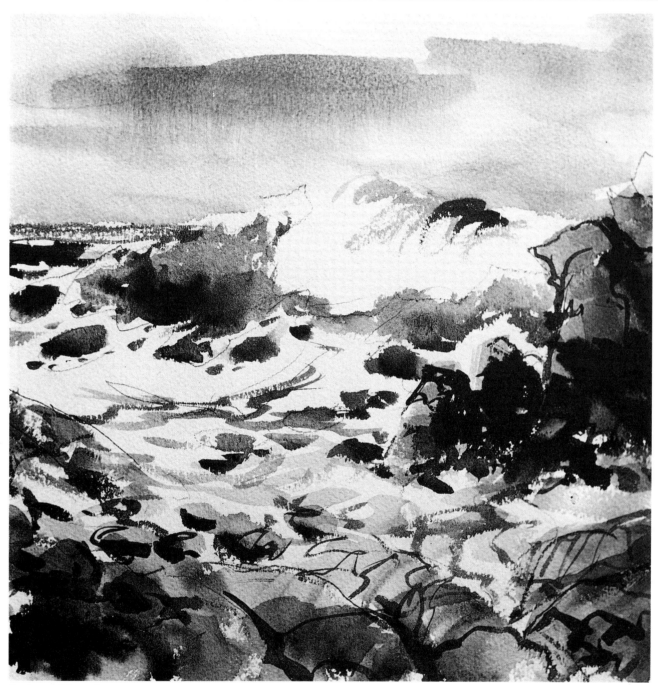

Rockport, Massachusetts.

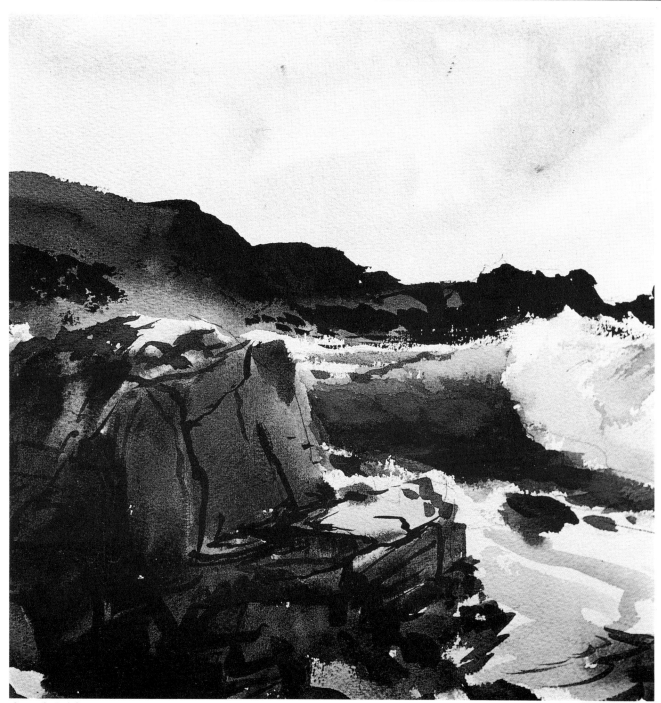

Carmel, California.

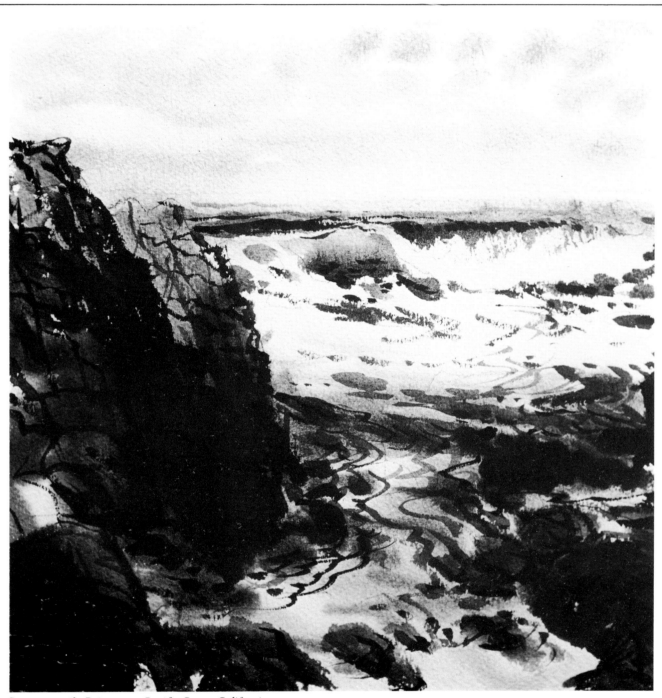

Seventeen-mile Drive, near Pacific Grove, California.

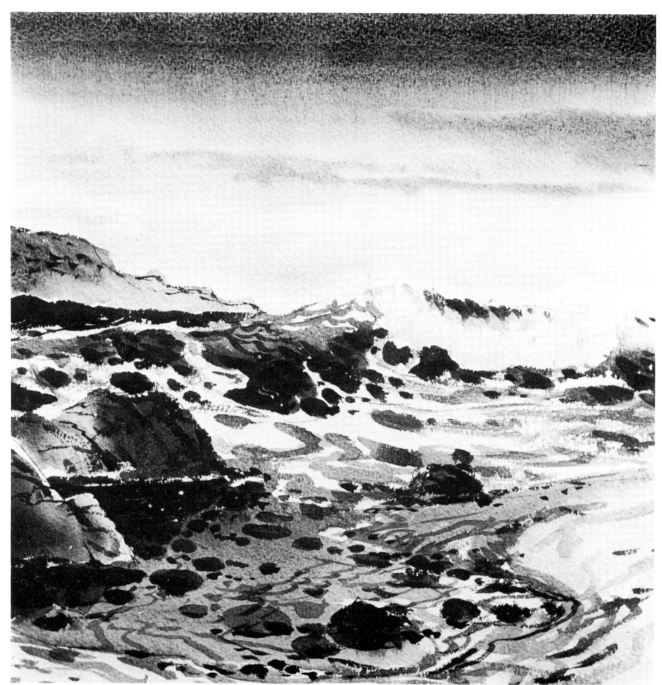

Cabo San Lucas, Baja, California.

Color

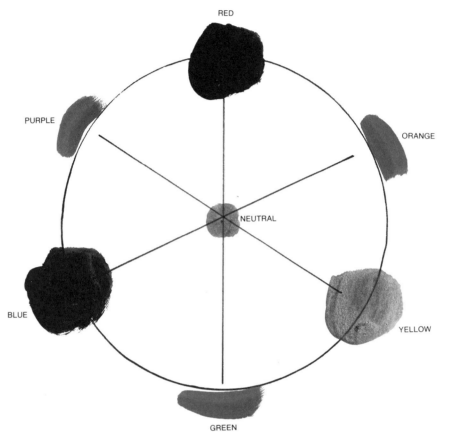

RED

ORANGE

PURPLE

NEUTRAL

BLUE

YELLOW

GREEN

The color wheel.

Basic Color Terminology
Let's take a quick look at the color wheel and go over some basic color terms so when I refer to a particular color or concept you will understand what I mean.

Primaries. The primary colors are red, yellow, and blue.

Secondaries. The secondary colors are orange, green, and purple.

Neutral. A neutral is any gray or gray-brown. Neutrals can also be created by mixing two complementary colors, such as orange and blue.

Complementary Colors. Any two colors directly opposite one another on the color wheel, such as yellow-purple, red-green, or orange-blue, are complements.

Adjacents. Any two colors next to each other on the color wheel, such

as red-orange or yellow-orange, are adjacent colors.

Tint. A tint is any color lightened by white.

Shade. A shade is any color darkened through the addition of black or brown.

Earth Colors. The earth colors are actually composed of pigments taken from the earth itself. Typical earth colors are: yellow ochre, raw sienna, burnt sienna, raw umber, and burnt umber.

Color and Mood
As we have seen before, mood can be expressed by line or value. But it also can be expressed through color. Most artists know that blue and green are cool colors and that red, orange, and purple are warm. Yellow can be either warm or cool, depend-

ing on which direction you may wish to slant it. Even purple can be shifted to the cool by the addition of more blue.

The moods that result from your color choices are partly dependent on the perceptions of the person viewing your paintings, but most people would agree that warm colors tend to create warm, happy, and sometimes active mood responses, while cool colors tend to be restful, quiet, and cooling to the viewer. A combination of warm and cool colors, however, may cause a variety of moods.

My love of simplicity almost demands that I paint with a limited palette and a limited color composition. I prefer to use one color to set the dominant note of the entire painting and complement it with its opposite hue on the color wheel. In addition, I often include an adjacent color for

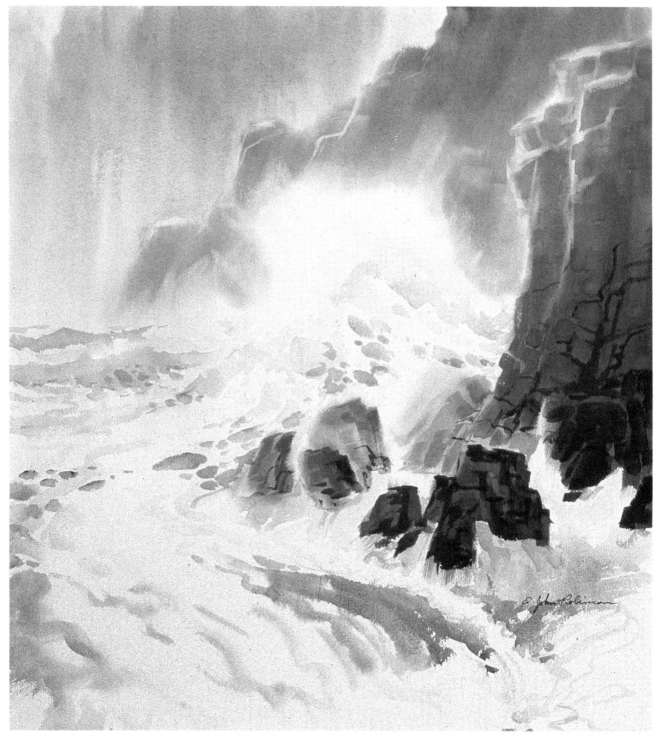

Storm Fury, 22″x22″ (56 x 56 cm), Grumbacher watercolor board, rough.

I intended this to be a moody painting, so I used sombre colors and chose a rainy day with little, if any, sunshine. The weather is stormy and the sea is wild. The surf has been whipped to a froth and the rocks drip and gush frothy water.

I achieved this mood by mixing cerulean blue and raw sienna for the sky. The paper was very wet and I tilted the board to let it "rain." I used the same approach on the rear headlands, but made wide, diagonal strokes there instead of vertical ones. The foreground bluff and rocks were a mixture of raw sienna and burnt umber. This was also applied as a wash, but it was later textured with linear details and colors when the paper was dry. I painted the sea with viridian and a touch of cerulean on nearly dry paper. I made the edges a little sharper there, especially in the foam patterns near the big wave, which is the center of interest.

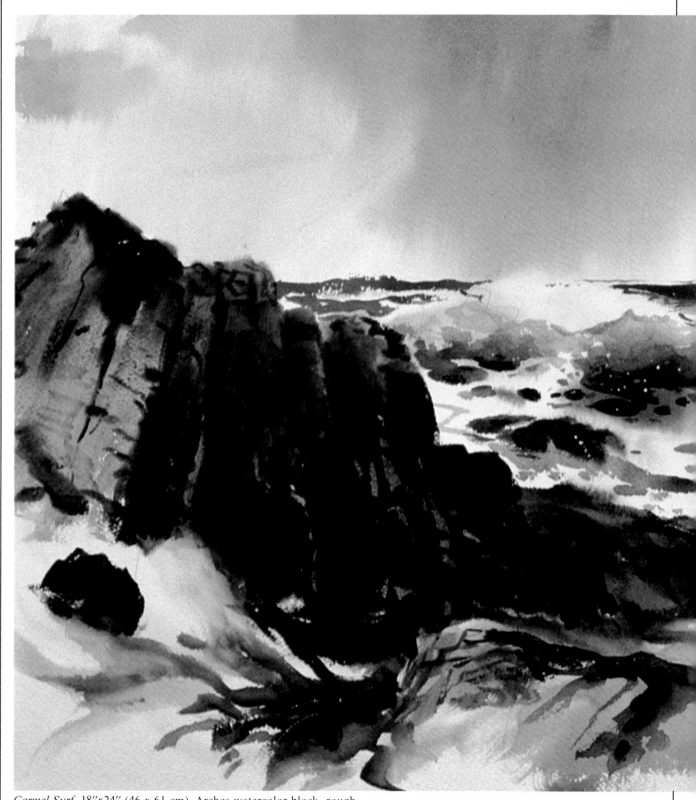

Carmel Surf, 18″x24″ (46 x 61 cm), Arches watercolor block, rough.

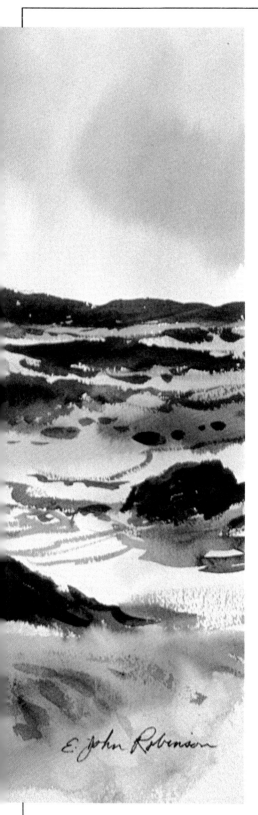

harmony. For example, in a painting that is dominantly blue, I may add smaller amounts of either green or purple. These hues are adjacent to the blue on the color wheel and so they harmonize with one another naturally since both purple and green contain blue. Now somewhere else in the painting I may add a spot of orange, which is the complement of the dominant color blue. Of course, the orange would be used much less than the the other colors.

If you observe nature closely, you may find many places to spot some of the complementary color in a painting. For example, in a seascape that is dominantly blue, earth-colored rocks may have a touch of orange. A bright color like this is especially effective near the center of interest where it will draw attention to a focal point that calls for something extra.

There are endless amounts of such color combinations, and you may want to experiment with many of them. Remember, you can make any color dominant and your colors don't necessarily have to harmonize. Also, you can use more than three colors. Many different moods can be expressed through subtle color changes and so only you can decide what color combinations are right for a particular painting. But at least, after experimenting, you will have some guidelines, a place to start.

A note of caution: Do a lot of experimenting, but do it on scraps of paper—not on your painting. There is nothing more inhibiting than the feeling that a particular painting must be successful. So experiment and learn first then use that information on a painting.

This is the largest watercolor block I know of and I use it frequently for outdoor painting. Once in a while my painting turns out just right on location and I don't have to re-work it in the studio. This is one of those paintings.

I love the rocks along the Monterrey coast. This time I made them a main feature, a center of interest, instead of a support to the water. To do this, I had to exaggerate the values to make them darker than the background. I also intensified the color: I made the raw sienna richer by adding mauve and burnt umber to it. Because I kept the sea lighter and less intense, the rock stands out. But the color of the foreground water had to be strong in order to support the rock area as the focal point.

Basic Seascape Elements

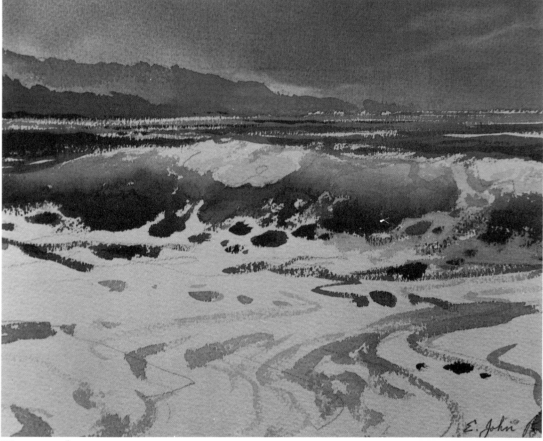

Wave example.

The seascape painter is concerned with three basic elements of nature: the sky, the sea, and the earth. Although each element has its own characteristics, each also interacts with the others. It is therefore important to understand each element before trying to paint it.

I prefer to emphasize the water in most of my seascapes, letting the sky and earth play a secondary role. But these other elements are important, too, so I will also devote space to them. In fact, beaches have so many particular characteristics of their own, I will discuss them separately. To complete the crucial bits of basics you will need to know before launching into the major painting demonstrations that follow in Part II, I will also include step-by-step demonstrations that show how to paint each of these subjects in color.

Since practicing these demonstrations will give you some skill and prepare you for work on your own, I suggest that you try them yourself before tackling your first seascape. By practicing them first, you may avoid a lot of problems later. For this practice work, use student-grade paper or the back of any "less-than-successful" paintings you might have lying around. Since the idea is to learn, not to produce an exact copy of these lessons, try to think in terms of experimenting rather than of trying to "make great paintings" at this point.

(Later, of course, you will think in terms of producing work of the highest quality.)

The sketch above shows the orchestration of all the wave elements that will be described. The energy that began from some distance from shore has reached shallow water and has lifted the water too high for it to support itself. The upper edge of the wave has now broken and is beginning to spill forward.

Notice that the foreground has turned into a mass of foam due to the agitation of previous waves. As the major wave lifts the foam, the foam splits apart into trails and holes. You may be able to see the color of the water in these holes.

Waves

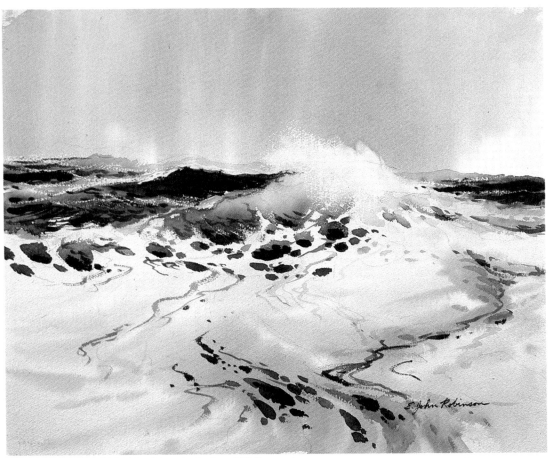

Foamy Surf, 18″ x 22″ (46 x 56 cm), Arches 300-lb rough paper.

When you stand on the shore watching the waves break, you are witnessing the end result of a transference of energy. This energy was formed by an action that took place earlier somewhere at sea, where energy was released by wind, by storms, by ships cutting their way through the water, or simply by the movement of the ocean's tides (themselves a result of the moon's gravitational pull on Earth). This energy is transferred to the sea and continues to move outward—like the concentric rings formed when a pebble is dropped into a puddle—until it reaches shore. There the shallowness of the ocean floor and its angle causes the water to roll or pitch forward and break against the beach. In other words, most of the energy the sea possesses has been received from other sources, and the sea then acts as a conductor of that energy.

Most of this energy exists below the surface of the water, which moves at a slower rate than deeper water. You can prove this by dropping a chunk of wood into the sea and observing its movement: the wood will merely bob up and down in place as swell after swell passes. Thus the movement of the wood, like that of the sea, is passive and receptive.

Swells

During a severe storm, swells can sometimes be gigantic—large enough to swamp great ships. Sometimes froth—known as "white caps"—churns at the crest of these great swells, and may even tumble forward. But these swells with their froth are not to be confused with true breakers, which appear only in shallow water.

As the energy propels the water toward shore, the swells move out from under the froth. The froth then flattens out on the ocean's surface and splits up into foam patterns. This lacy-patterned foam is then picked up by the following swell and is tumbled again.

Swells may travel for a thousand miles or more before they reach a shoreline. Since larger swells travel faster than smaller ones, they may overtake the smaller swells and pass right over them.

The distance between swells is called the "wave length." The wave length is determined by how close the swells are to the source of energy that created them. If it was a storm that caused the ruckus and if it is still nearby, then the swells may be close together and fresh enough to be large and active. If that storm is farther out to sea, the swells may be smaller, farther apart, and probably less active.

At this point, you may well be wondering why all this is important, but you will soon see how the energy of the sea shapes the waves and causes the breakers. With this understanding, you will not be likely to paint foam on a wave face where it doesn't belong or have your waves breaking toward China, both of which errors I have seen in amateur paintings.

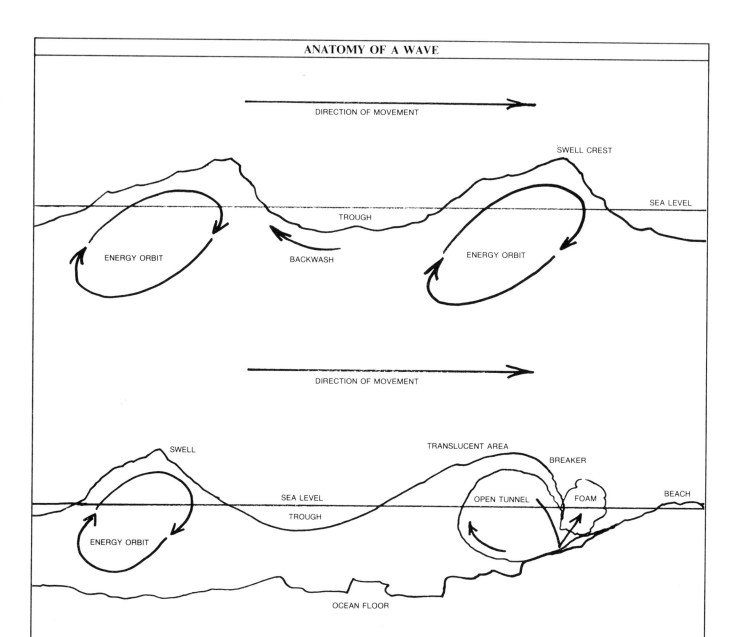

Energy Orbits (top). This side-view diagram shows how the near-circular orbs of energy create swells. The energy moves along and approximately one quarter of it rises above sea level. This causes the water to move upward or "swell" as the energy passes by. In other words, the energy actually lifts up the water.

If you are still confused as to how this energy moves along, lay a blanket on a table and push a broom handle along the table top underneath the blanket. The broom handle forms a ripple in the covering blanket in much the same way that energy molds the sea into swells.

The Breaker (above). As the orb of energy reaches shallow water, a change takes place. The rising angle of the ocean floor causes the water to rise upward with it. But eventually the water is pushed beyond the stability of its form and it "breaks."

In this diagram of a breaker, you can see that the tunnel formed by the wave is nearly the shape of the energy orb. As the water breaks and peels over it, the water gets thinner there—at the top of the tunnel—than at the base. It is the thinness of this area that allows the light to pass through it, which gives the tunnel that translucent effect seascape painters love to paint. (Later I will demonstrate in color how to paint a translucent wave.)

Looking at the diagram, notice also that as the water "peels" forward, it hits the trough of the wave and bounces back as breaker foam. (The portion of the wave that is falling may also be foamy, but that is only because air is mixing with the falling water.)

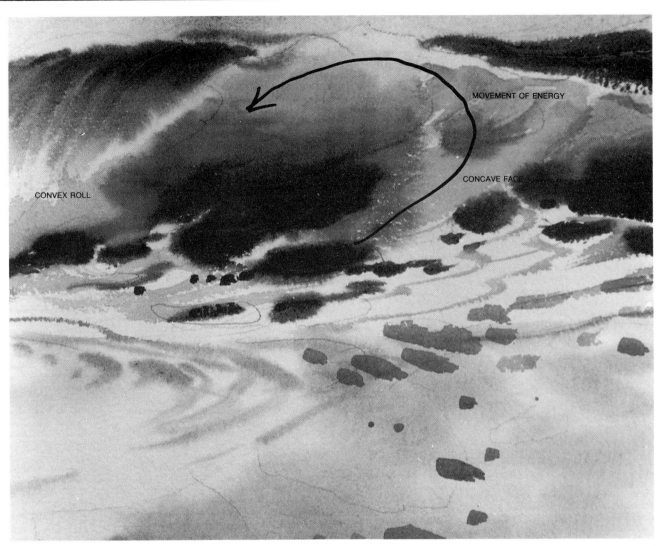

CONVEX ROLL

MOVEMENT OF ENERGY

CONCAVE FACE

Breaker Example. This view of a breaker shows the results of the energy orbit. Notice that the waveface is concave or hollow. The roll is convex, the result of the wave crest falling forward. The tunnel of air surfers call the "pipeline" is between the roll and the wave face.

Notice also that the roll becomes lighter in value as it nears the base. This is because, as it falls, the water has become thinner and has mixed with air. The upper portion of the waveface is lighter too because the water there has thinned out and the light passes through it as it would a window. This is the translucent area of the wave.

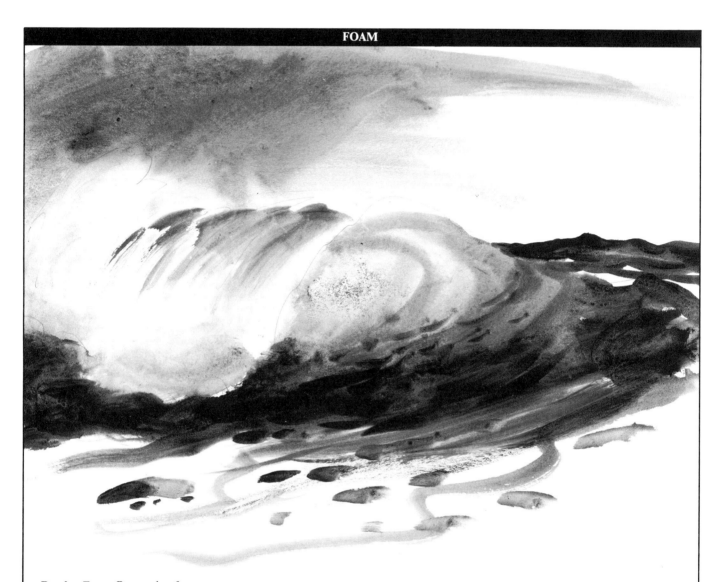

Breaker Foam. Remember from the preceding page that the action of the breaker caused foam to form as the water peeled over and struck the trough? This sketch shows another example of this effect.

The wind can also influence breaker foam. Here on the left you can see a mistiness. As the foam hits the trough and bounces up, the wind may catch it and whip it well above the height of the wave. Sometimes the wind can whip the foam back for quite a distance as the wave continues to move forward. These trails of foam that float in the air are called either "mares' tails" or "horse tails," depending on the local expression for it.

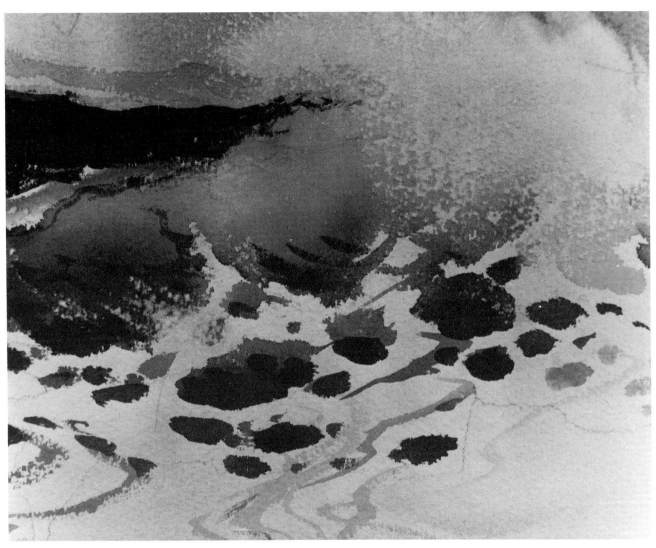

Foam Patterns. Foam patterns are the result of wave action in the surf. As the water moves, some of it is churned into foam that then rides on the surface of the ocean. Each wave that comes in lifts the foam, causing it to split apart into trails and patches with many holes. The wave then breaks, moves up the beach, then flows back to meet the next wave. The backwash meeting the oncoming wave creates most of the foam that becomes patterns.

This is a close-up of a sketch showing a few patterns on the wave face. Notice that there is a lot of foam with only a few holes at the base. But further up the wave, the lines are thinner and the holes get larger. This is because the wave is rising and stretching the blanket of foam.

1. As usual, I first make a brief outline in pencil—the fewer marks, the better. Then I wet the paper with a sponge. Now I mix cerulean blue with just enough raw sienna to gray it. Remember, earth colors like raw sienna are neutral, but they contain a bit of orange which is the complement of blue, and therefore grays it.

With a 1″ (25 mm) flat brush, I dip into my mixture and begin the sky. I start in the left-hand area and quickly wash the color across the paper, using diagonal strokes. Because the paper is wet, the brush loses color as it moves, so the sky gradually fades from dark to light. I am especially careful, however, to make the sky dark behind the area of foam. Then, with cerulean blue, I paint the shadow on the wave face, then darken the area under the foam with ultramarine blue. Since the paper was still quite wet, I do not have to re-wet it. I was careful not to tilt the board, so my colors did not run.

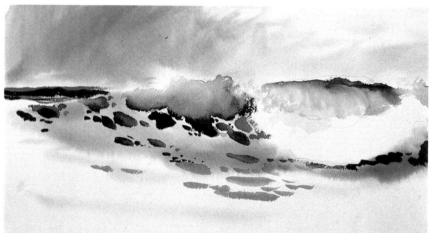

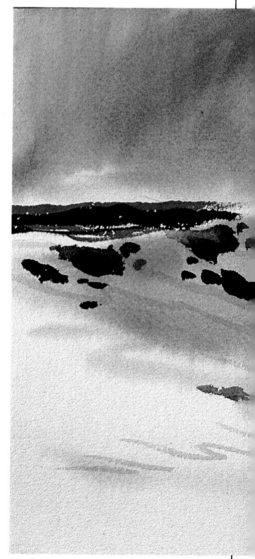

2. For this step, I let the paper dry first. As it is drying I use my sponge to blot up any sky color that starts to run down the paper into the wave foam. Although many different greens could have been used, this time I use Hooker's green for the wave color. With a no. 12 round sable and with some water on the brush, I dip into the green. Starting paint at the base of the wave and working upward, I first paint the holes in the foam, some small and some large. Then, in the open part of the wave, I add water to my brush. I always add more water as I work upward. The water thins the paint at each stage, fading the color and giving the impression of translucent water.

I also use Hooker's green to show the roll of the wave. Starting at the top of the wave with dark green I add only water to the brush and gradually lighten the color as the wave goes down toward the foam. I then underscore the foam with some dark green water to show depth.

3. For this final stage I add some dark ripples to the wave with the tip of my no. 12 brush and make a few short scallops just above the foam patterns. I also complete the breaker foam by shading it. Starting at the bottom of the breaker, I paint the shadow with the no. 12 brush and cerulean blue. I paint upward on dry paper, adding water but no paint as I go. The blue shadow fades into the white paper well before it reaches the roll. I finish the wave by adding a few cerulean blue rippled lines to the shadowed foam patterns and the foreground. I also nick in a few highlights on the wave with the tip of my knife.

You may need to practice these steps several times in order to feel comfortable with them. Frustration with poor results is a good sign that you should try again. Just be persistent. It will come.

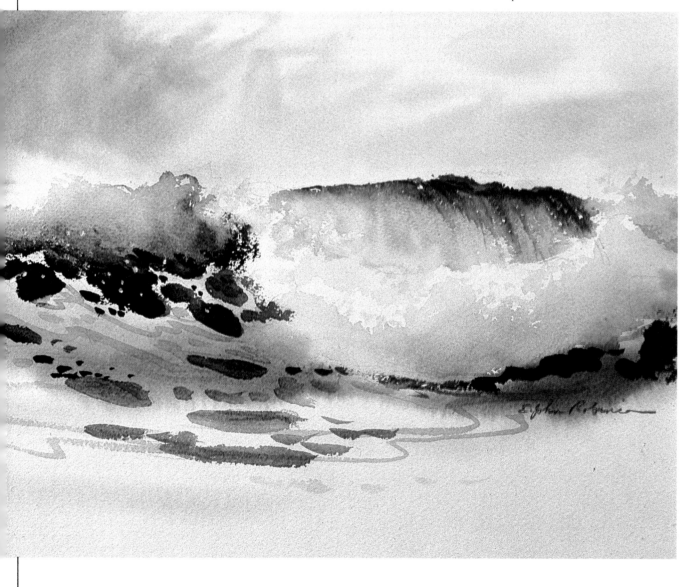

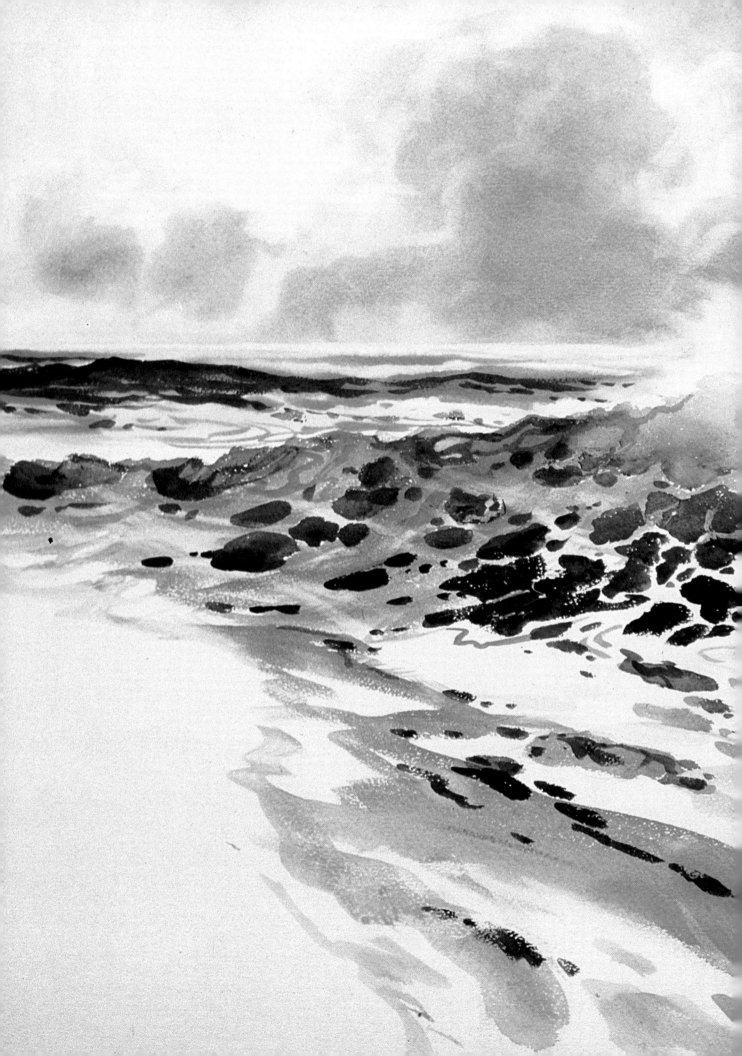

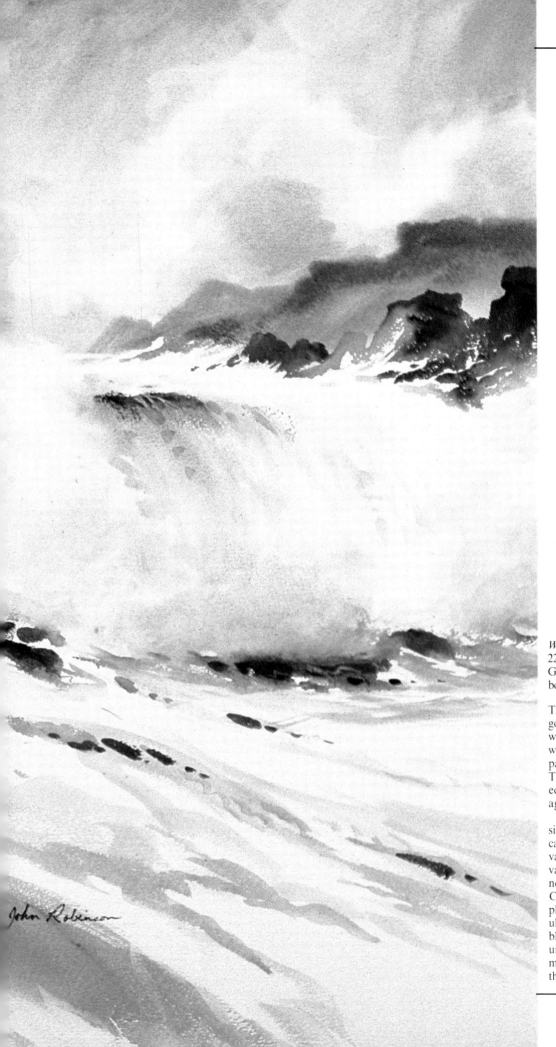

John Robinson

Winter Waves,
22″x30″ (56 x 76 cm),
Grumbacher watercolor
board, rough.

This painting provides a
good example of a breaking
wave. You can see how the
wave has built up and that
part of it is rolling forward.
The breaker foam has soft
edges and whips back
against a darker sky.
 The composition is
simple: The wave is the fo-
cal point and is darkest in
value. The light and middle
values are used to support,
not detract from, the wave.
Color-wise, it is even sim-
pler: I have used viridian,
ultramarine blue, cerulean
blue, and burnt umber. The
umber is an earth color and
makes a fine complement to
the blue.

Rocks and Headlands

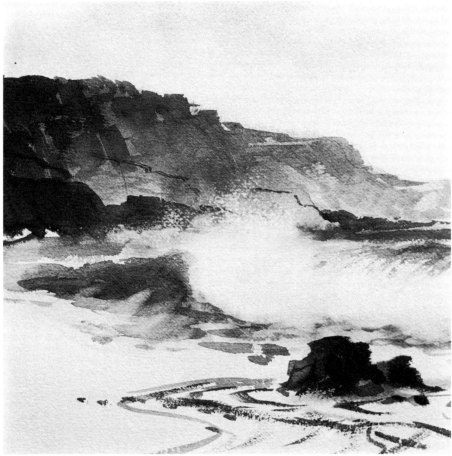

Rocks and headlands example.

Rocks are the last remnants of what was once a shore. When all the softer materials on them have eroded away, the rocks, too, will eventually crumble. The sea is relentless. Bit by bit, piece by piece, in time mountains are reduced to plains and rocks become the grains of sand on the beaches. This erosion must be taken into account and expressed somehow in a seascape. I like to paint most rocks as hard lumps, ironically battered by the softer-appearing water. I make their edges broken and crumbling, and texture them with cracks and pock marks, scars from the relentless action of the sea.

In a sense, headlands are really only large rocks. They are the fingers of land still hard enough to resist the sea. If they are tall enough to be out of reach of the waves, they may have trees and shrubbery growing on them. But eventually, however, like the rocks, they too will crumble be-neath the onslaught of the sea. Although they will erode slowly, some future artist someday may paint them—when they have been reduced to mere rocks—while standing on pebbles that were once the rocks we painted.

This never-ending struggle between land and sea has become a theme in most of my paintings. Sometimes I show the power of the sea as it thunders in against the land. Then the rocks are low and battered and the headlands soft and crumbling. At other times, I may show the land as stable and enduring. I place them high above a gentler sea. I give them a stolid look, with strong bases and leaning outward against the attacker.

However you choose to paint rocks and headlands, do consider them as more than areas on your paper. Give them a position in relation to the sea and sky. Give them a shape and a personality. You can show them, for example, succumbing or resisting the sea, or as beautiful objects with special characteristics. Let the sun shine on them, let water trickle through the cracks or pour from the sides. Let them reflect in tide pools or be awash with a collapsed wave. Give them the dignity they deserve. They are, after all, the earth.

The rocks and headlands above take on a slightly different form: a combination of a distant headland with a foreground rock. Between the two areas there is a breaking wave. Because of the contrast between the light wave and the dark rocks and headlands, the wave easily becomes the focal point. To achieve the effect of ocean spray, I sandpapered the upper portion of the foam. This had to be done on very dry paper and over a somewhat dark area in order for it to show.

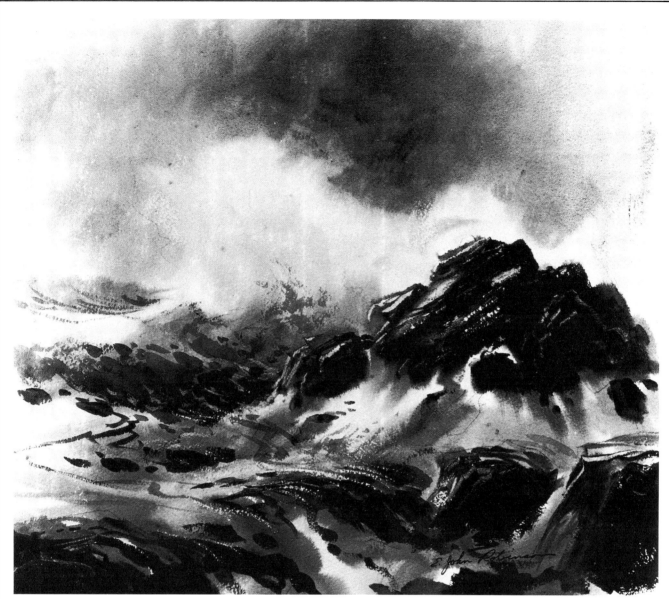

The Burst, 16″ x 20″ (41 x 51 cm), Arches 300-lb watercolor block, rough.

There is nothing like a wave bursting against a rock for pure drama. To enhance this I deliberately darkened the sky to make the foam appear more distinct. Also, the contrast between the foam, which is the lightest area, against the rocks, which is the darkest area, confirms their role as the central attraction.

Notice also that the slant of the foam is opposed to the slant of the rocks. This is another way of depicting the age-old struggle between the opposing forces, sea and land.

1. When painting a rock, you must keep in mind the direction the sunlight. This will determine its lightest side and, of course, its shadow side. I first outline the rock, then paint a value behind it, in this case a middle value of blue-white. I place it against the lightest side of the rock for contrast. I then underpaint the entire rock, except for the area that will be sunlit. For the underpainting, I mix a light-to-middle value of raw sienna plus a touch of the same blue I used in the sky, here ultramarine blue. Notice that I include a tide pool in this demonstration. I outline a corner of the pool with raw sienna and paint the reflection with the same color I used on the rock.

2. While the underpaint of raw sienna-blue is still wet, I mix a darker portion of the same mix; that is, more paint, less water. With a ½″ (13 mm) flat brush I touch in the shadow side, both on the rock and in the reflection. Notice that the rock isn't sidelit (half in light and half in shadow) but, rather, is backlit. That is, the rock will be mostly in shadow when I'm finished, with a thin edge of sunlight and a fairly large area of reflected light. The reflected light is caused by light hitting the sand and bouncing back into the shadow side of the rock. These reflections lighten the shadow side considerably, but not nearly so much on the sunlight side.

3. The final stage of painting rocks is adding textures. These include cracks, crevices, small holes and even glints of light, which I get by nicking the surface of the paper with the point of a knife or razor blade. I allow the paint to dry before adding texture because I want the lines and spots to be crisp-edge. After it is dry, I add texture with a no. 4 round sable brush with a sharp point and the same rock color—raw sienna and blue. However, rather than make all textures the same value, I vary their values, making each line only slightly darker than the area it rests on. That means, of course, that the texture lines in the light areas will be much lighter than in the shadowed areas. (Don't forget to reflect a few lines in the tide pool, too.)

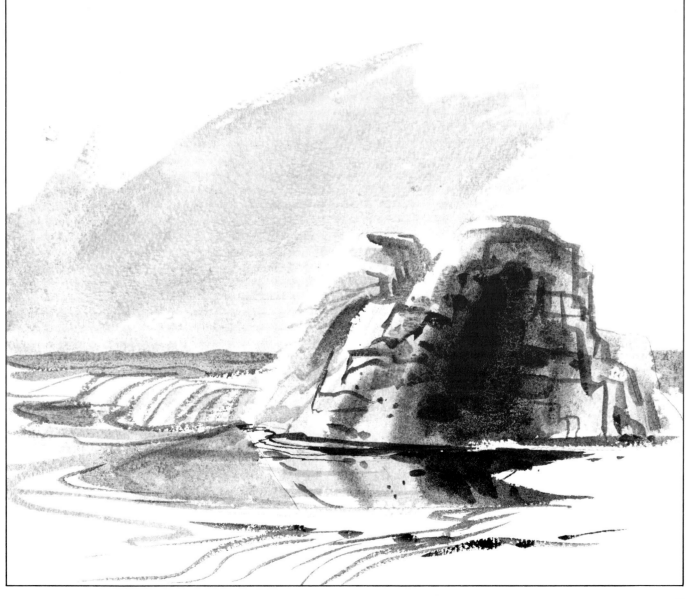

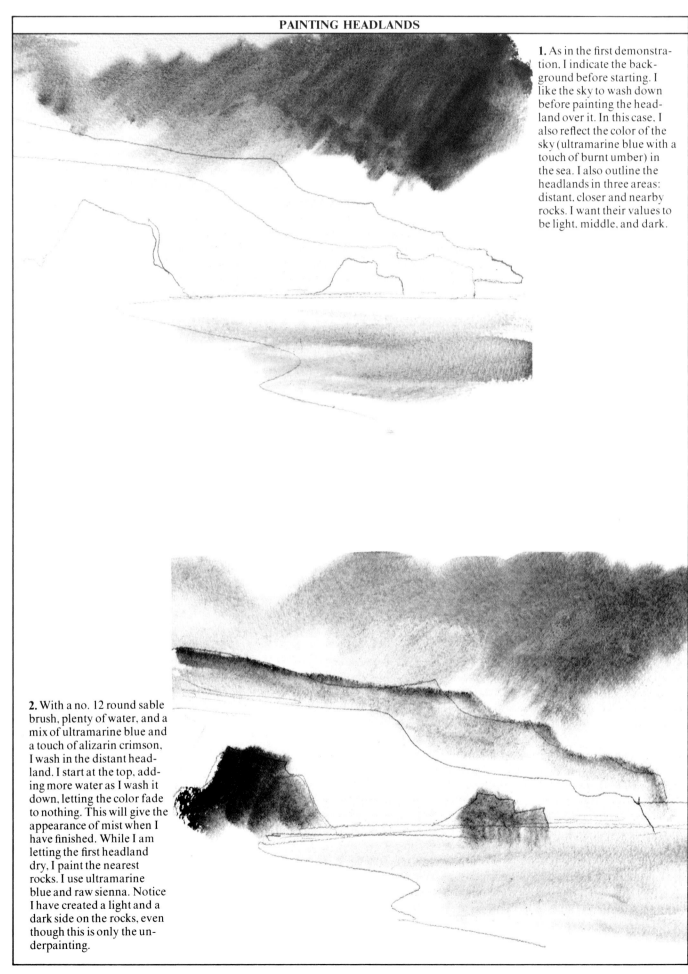

1. As in the first demonstration, I indicate the background before starting. I like the sky to wash down before painting the headland over it. In this case, I also reflect the color of the sky (ultramarine blue with a touch of burnt umber) in the sea. I also outline the headlands in three areas: distant, closer and nearby rocks. I want their values to be light, middle, and dark.

2. With a no. 12 round sable brush, plenty of water, and a mix of ultramarine blue and a touch of alizarin crimson, I wash in the distant headland. I start at the top, adding more water as I wash it down, letting the color fade to nothing. This will give the appearance of mist when I have finished. While I am letting the first headland dry, I paint the nearest rocks. I use ultramarine blue and raw sienna. Notice I have created a light and a dark side on the rocks, even though this is only the underpainting.

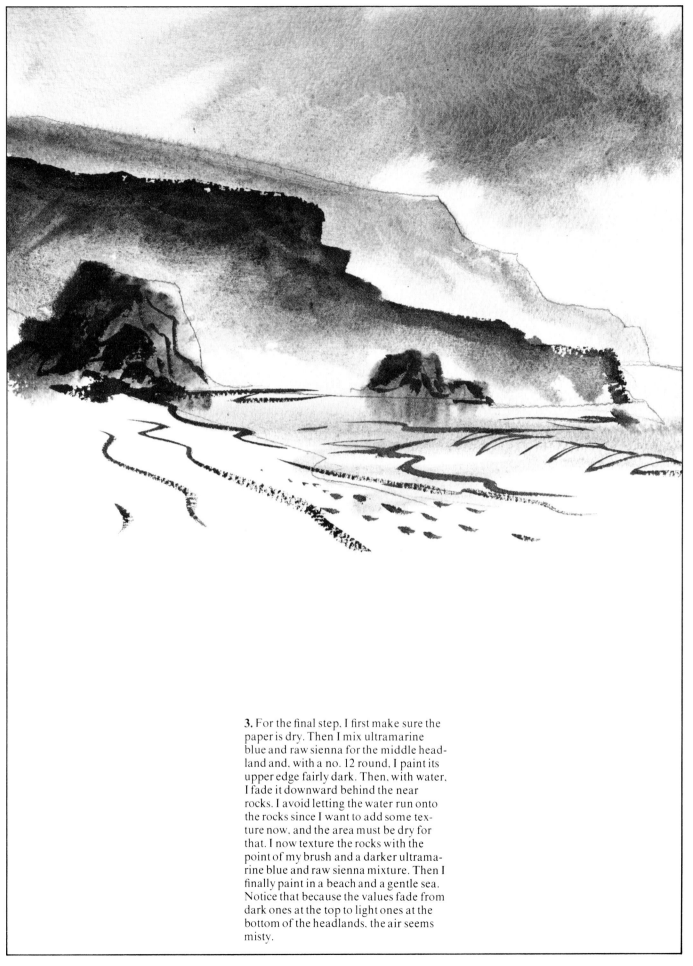

3. For the final step, I first make sure the paper is dry. Then I mix ultramarine blue and raw sienna for the middle headland and, with a no. 12 round, I paint its upper edge fairly dark. Then, with water, I fade it downward behind the near rocks. I avoid letting the water run onto the rocks since I want to add some texture now, and the area must be dry for that. I now texture the rocks with the point of my brush and a darker ultramarine blue and raw sienna mixture. Then I finally paint in a beach and a gentle sea. Notice that because the values fade from dark ones at the top to light ones at the bottom of the headlands, the air seems misty.

1. I begin by wetting the paper thoroughly with the sponge. With the paper very wet, I paint in a quick sky. I use a 1″ (25mm) flat brush and manganese blue at first. Then I darken it with a touch of ultramarine blue and paint a deeper blue spot in the sky, then work downward toward the sea. I apply the darker blue to the background sea, foreground foam, and shadow under the rocks. Now I underpaint the rocks and headland.

To paint the headland, I use raw sienna with a touch of manganese blue to gray the color. I start at the left with the darkest paint and make it lighter as I move to the right. The paper is still wet but not drippy, so additional water is unnecessary. I paint the rocks with the same mixture I used for the headland and a no. 12 round sable brush. Note that I leave the left side of the rocks unpainted. This is the side that will be lit by the sun.

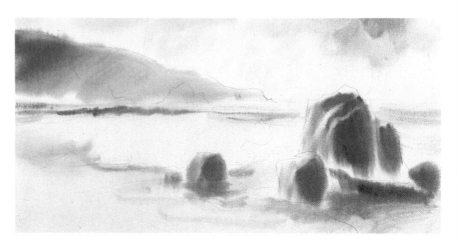

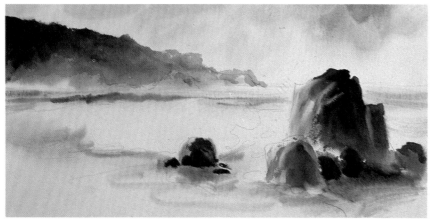

2. For this step, I want the paper to be nearly dry, though I am not concerned about the colors running a little. With a no. 12 round, starting at the upper left, I darken the headland with more raw sienna and manganese blue. I lighten the color as I work down and to the right by adding water to the brush. I then shade in the right side of the rocks with the same color. In case you are wondering why the headland is shadowed on the left and the rocks on the right, the reason is that I want the sunlight to come from beyond the headland, over the central area. The headland may fade into the atmosphere on the right, but the sunlight strikes the rock on the left. Also, notice the blue in the raw sienna. The shadow on the rocks is darker than the headland because they are closer. There is more atmosphere to see through to the shadows on the headland.

3. To make the distant headland seem even more distant, I add a few rocks in front of it in the foreground with raw sienna and a touch of raw umber. I also add a few textural lines to the headland using the point of my no. 12 round. I also texture the foreground rocks with the same color and brush. I then brush in the wave just as I did in the wave demonstration, using cerulean blue for the foam and Hooker's green for the wave. The foreground swirls around the rocks are manganese blue to reflect the sky. Where the swirls go under the rock, I add a touch of raw sienna to reflect the rock color. The final touch is a few nicks of the knife point for a bit of sparkle on the rocks and the wave.

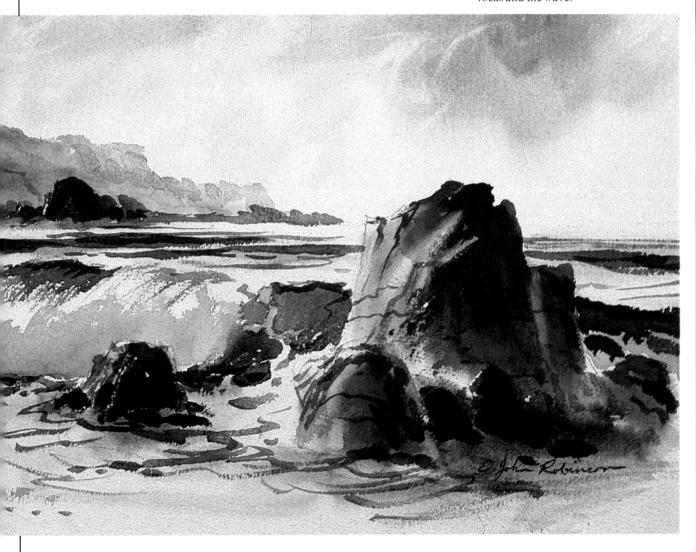

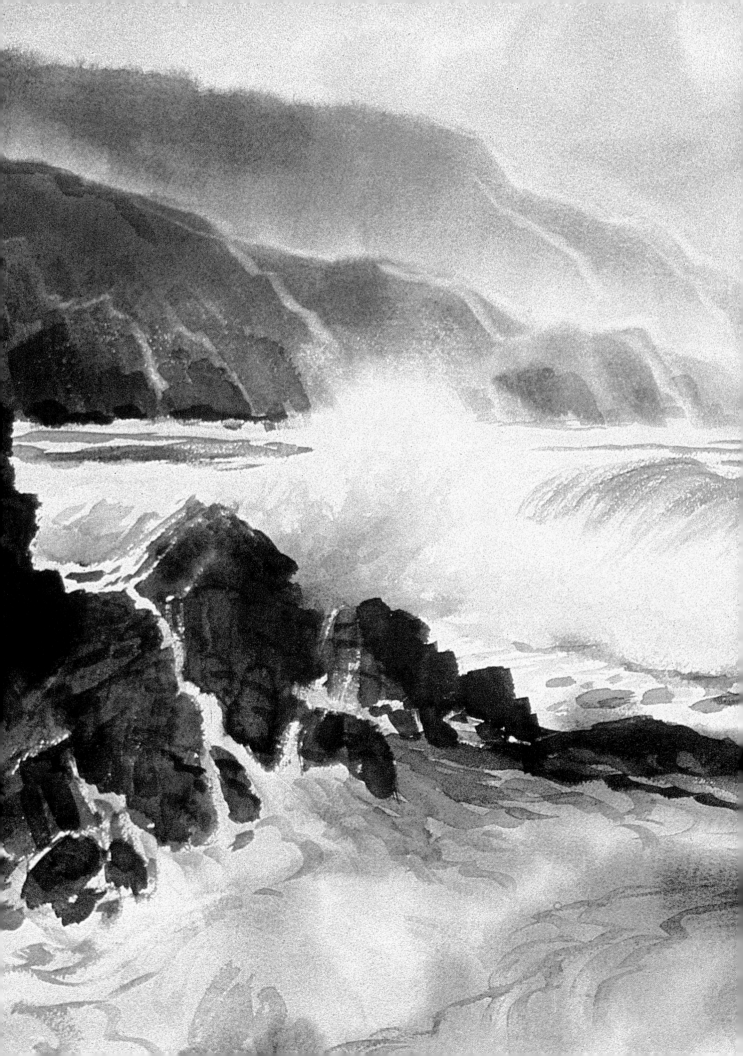

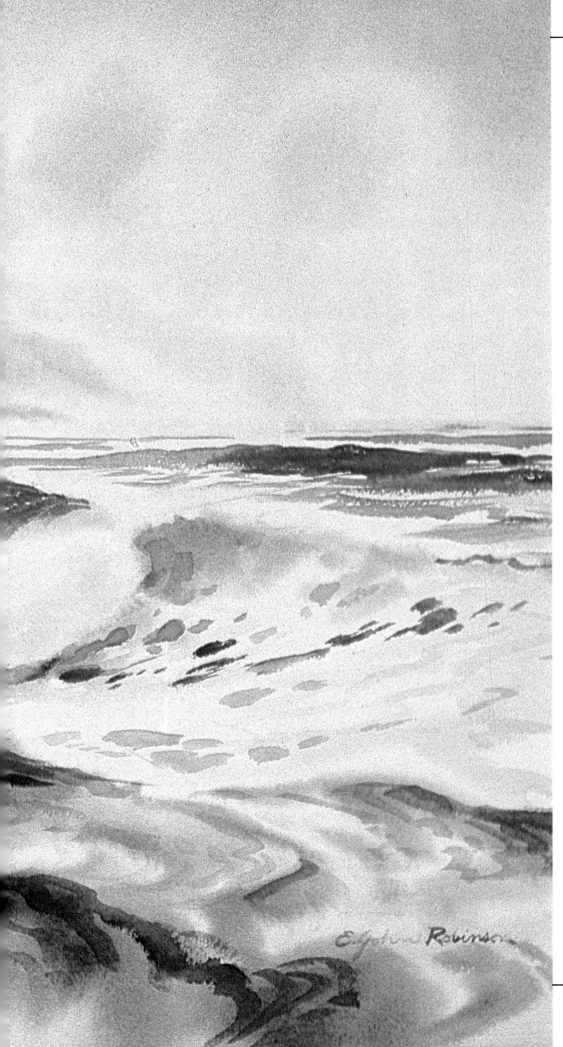

Big Sur Country,
22″x30″ (56 x 76 cm),
Arches 300-lb rag
paper, rough.

There are three head-
lands in this painting and
each one gets progres-
sively lighter in the dis-
tance. This is an impor-
tant point to remember
when painting a sea-
scape—that atmosphere
reduces the intensity of
color and detail. In this
case, it has changed the
blue-brown headland to
a bluer, lighter, and al-
most invisible, distant
color. The rocks are of
the jagged-edge variety
and I lined them up
directly in front of an on
coming wave. There is a
psychological anticipa-
tion when a soft-edged
wave is about to meet a
hard edged rock that
causes the viewer to
think of the next mo-
ments and wonder about
the outcome. Notice wa-
ter from the preceding
wave still trickling off the
rocks.

Skies and Clouds

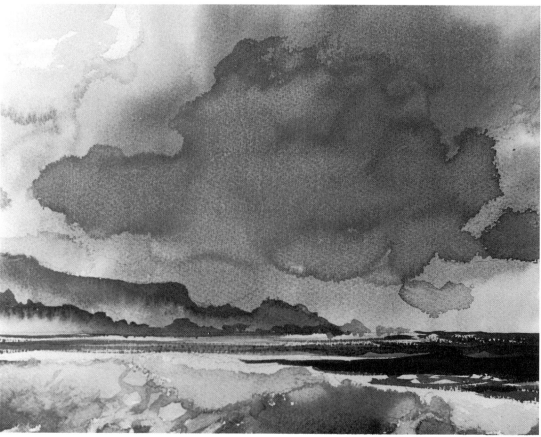

Skies and clouds example.

We have already talked about the three elements a seascape painter is concerned with: earth, sky, and water. However, we have not yet talked about the importance the sky may play in a composition.

The sky is more than an area above the sea and much more than mere background. It forms the atmosphere of a painting because in order to see objects from one inch to ten miles away, you must look through varying amounts of atmosphere. The sky (or atmosphere) contains moisture and other particles and breaks up the sunlight into short wavelengths that are basically blue. Therefore the more sky you must look through to see an object, the less distinct the object becomes and the more the color of the sky affects it.

The sky also influences the color scheme of the seascape. The sea is transparent and can only reflect what is above and below it. So whatever color is in the sky must be reflected from the surface of the sea. The only

exception is when the sea rises as swells and breakers. Then, the more vertical waves do not reflect the sky except indirectly, as bounced light—that is, as sky color reflected off other waves or objects.

Finally, the sky sets the mood of your painting. First, the color temperature of the sky—whether it is warm or cool—affects the mood. Then the directions of the lines in the sky—vertical, diagonal, horizontal, curved, and so forth—influence the overall feeling of the work. And finally, the type of weather you choose—stormy, calm, or sunny—sets the general mood of the scene.

Watercolorists love to do drippy, wet skies. They are fun to do, as you will soon see, and they are also particularly conducive to the medium of watercolor. But the problem is that a drippy sky does not fit all situations. For one thing, drippy skies invariably have vertical lines. But where you have a composition with lots of horizontals, a vertical sky would be out of harmony.

You must keep the mood of your painting and the overall composition clearly in mind when you paint. The direction of your brushstrokes, cloud shapes, and other movement in the sky should enhance—not fight—the directions in the rest of the composition. A sky may be vertical, horizontal, or diagonal in shape, or may contain a series of clouds that create moving, sweeping lines. So before you begin to paint, work up a thumbnail sketch and think twice about the movement of the clouds or the type of sky you will need.

The illustration above is a close-up of a portion of a sky in a painting. It is a combination of a drippy sky with basic clouds. First I painted the background sky as a series of light clouds. I allowed them to drip so that they did not have hard edges. Next, before the paper was completely dry, I painted the darker, cumulonimbus cloud. Because the paper was still damp, the edges of the cloud ran just enough to keep them soft.

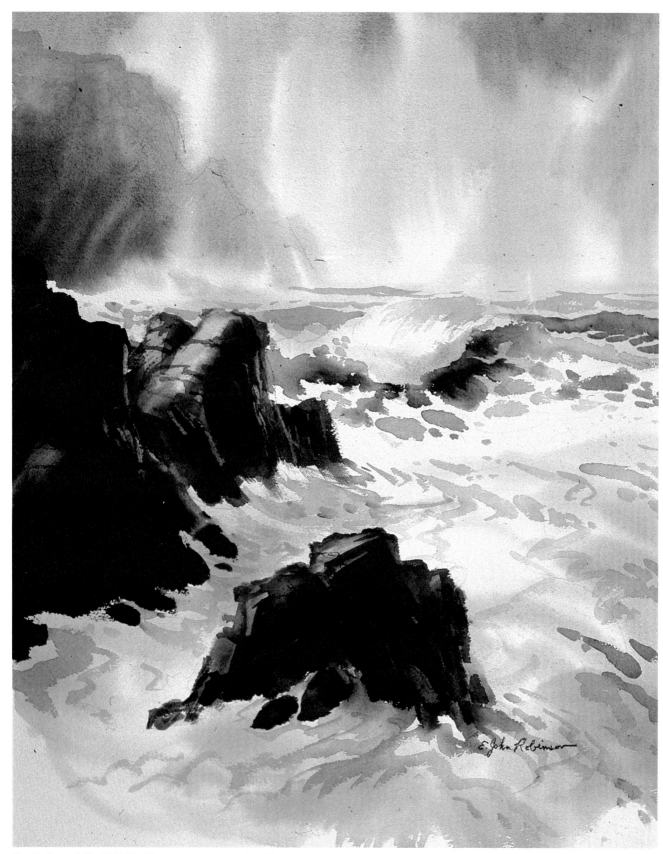

South Coast, 24″x18″ (61x46 cm), Arches watercolor block, rough.

Misty air is quite common along the coast, especially where waves constantly beat against rocks and headlands. To paint this misty effect, the color of the atmosphere must be carried through the entire painting and you must work on very wet paper so edges are kept soft.

I first painted the sky with ultramarine blue and a touch of burnt sienna. I used the same colors for the bluffs but with a little less water. This made it slightly darker but with the same atmosphere as the sky. (I don't use dark colors or sharp edges until I reach the foreground.)

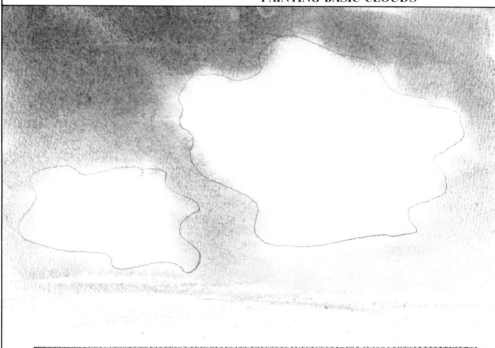

1. Before painting clouds, I lightly draw their outline as a guide. Clouds have a nebulous form, so their shape is free-form. I try to avoid square shapes and anything that looks too geometric. Also, I vary the sizes of the clouds; different-size clouds make for more interesting areas. After I have outlined the clouds, I paint in the background sky. I wash the entire paper with water then paint the sky color with a large brush, in this case a 1″ (25mm) flat Aquarelle brush. I start at the top of the page with dark cerulean blue and wash it down with more horizontal strokes, avoiding the area of the clouds. If too much paint runs into a cloud, I wipe it out with a sponge. But I don't mind fuzzy edges. They help give the clouds a soft appearance.

2. Now I paint the interior of the cloud and put in any other clouds that don't need light edges. To do this, I first re-wet the area of the clouds, being careful not to touch the dry sky area. Then I mix a gray-blue shadow with ultramarine blue, a touch of alizarin and a touch of yellow ochre. Using a no. 12 round brush, I start at the top with a thinned mixture of shadow color, gradually adding more paint as I work downward. This gradual darkening gives the effect of heavy moisture and deep shadows beneath the clouds. Finally, I add a few horizontal stratus clouds with the same color and brush. The final effect is that of a fleecy-edged cloud holding a hint of rain.

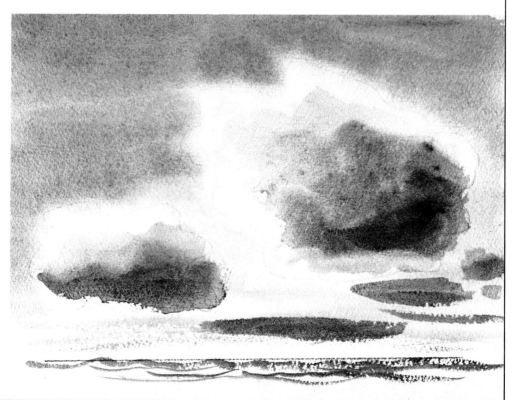

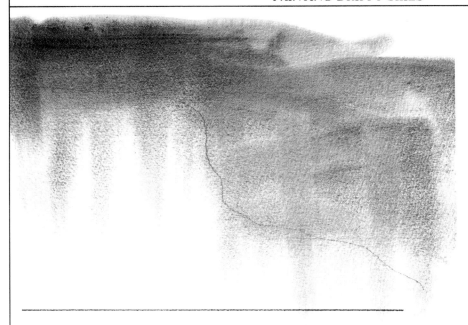

1. This is the watercolorist's old standby, the wet, wet sky. The drippy sky is fun to paint and it's all done like magic! I begin by drawing a light line for the base of the cloud to guide me. Here I made a casual loop so that the rainy cloud has a high and a low edge. Next, I wet the paper, wait a moment, then wet it again. I need plenty of water for this. Then I mix a middle value of cerulean blue, adding a touch of alizarin for a slightly purplish tint. Now, with either a 1″ (25mm) flat Aquarelle or a 2″ (50mm) varnish brush, depending upon the size of the area I am going to paint, I apply the paint. I start at the top of the paper with a quick, horizontal stroke. Next, I tilt my board so the paint begins to run. Then I dip into more paint and add vertical strokes. I start them at the top and lift the brush before they reach much below my guideline. Now I just let the paint run. I watch carefully and gradually return the board to a horizontal position when I want all the running to stop.

2. It is important to allow the first step to dry completely before beginning this next step. This is because by this time the water is beginning to evaporate. There is not enough of it left on the paper to permit another layer of paint to be applied without the new paint mixing with the first layer. Also, to add more water at this stage would wash out the paint of the preceding step.

When the paper is completely dry, I re-wet it with a 2″ (50mm) brush. (I don't use a sponge because it may dig into the paint and remove some of it. Now, with a large, flat brush, I dip into a deeper blue than the first one, in this case an ultramarine blue with a bit of raw umber and less water in the mixture. I apply the paint as I did in Step 1: I start at the top with a broad, horizontal stroke, then I make a few vertical strokes and tilt the board so the mixture runs. (I may add more water if necessary to get it to run down the paper.) I then watch the paint carefully and when I don't wish the paint to run any farther, I return the board to a horizontal position. The results should make you break out the umbrellas!

I especially like the effects I can get by varying the colors in the washes. For example, in this case I had a light value on the lavender side topped by a darker value on the blue-gray side.

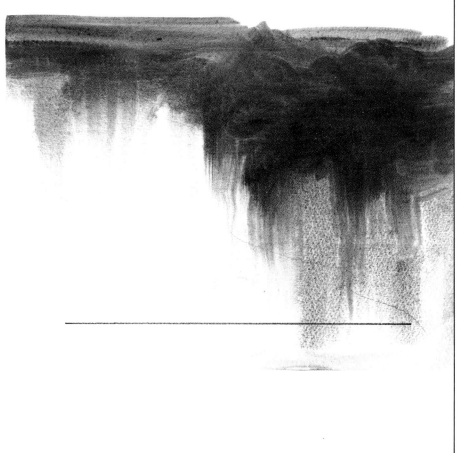

1. Since I am showing how to paint clouds, I will show very little sea. After I pencil in the bulging outlines of cumulus clouds, I wet the paper lightly with a 2″ (50mm) flat brush. (I don't need a dripping paper for these clouds.) Then, mixing cerulean blue with a bit of yellow ochre, with a 1″ (25mm) flat Aquarelle brush, I make sweeping strokes diagonally from the left to the clouds. Just above the clouds, I add more cerulean to the mixture and darken the sky above the area I wish to leave unpainted. I then lift off the edges of the clouds with a clean sponge. Above the cumulus clouds, I lift out a few wind clouds, this time with the edge of the sponge. By now the paper is becoming dry. I quickly paint an horizontal line with cerulean blue and a touch of ultramarine.

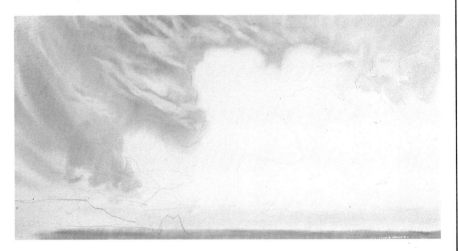

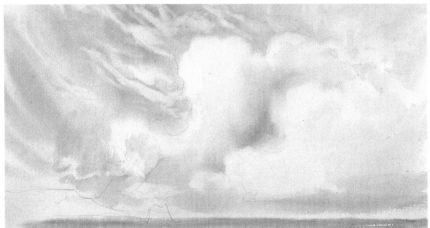

2. Since this cloud mass is too large, I must break it up. I re-wet the main cloud mass lightly with the sponge. Then, with the 1″ (25mm) flat and more cerulean and ochre, I paint in the shadow of the upper cloud mass. I stop it at the bottom where I have decided that I want another edge of clouds. Then I shade in the lower mass of clouds as I did above, right down to the horizon line. The result is a two-part cloud mass, both parts with light, billowy clouds, slightly shadowed.

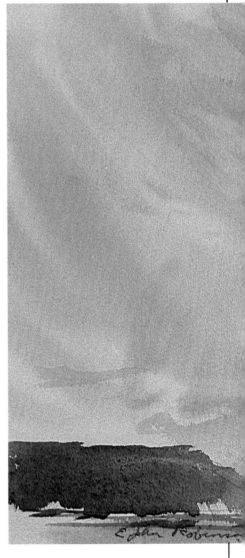

3. Adding a second or lower mass of clouds gave the sky some depth. The addition of low stratus clouds will give it even more depth. Stratus clouds are really more common over the sea than cumulus, but both types are possible.

I leave the paper dry for this and pick up my no. 12 round sable brush. Then I mix a touch of yellow ochre into ultramarine blue—I want these clouds to be slightly darker than the others. Putting plenty of water in my brush, I apply the paint with straight, horizontal strokes. I make all the clouds a different length and thickness for variety. Finally, I paint in a distant headland with raw sienna and a touch of blue, much the way I did in the last demonstration.

Practice a few skies with different types of clouds. Also vary your colors and arrangements. But be careful when you use the sponge. Use it lightly or the paper will take on a sponged look.

(Overleaf) *Full Tide,*
14″x20″ (36 x 61 cm),
Arches watercolor block, rough.

Skies reflect moods and set the stage for the sea, which in turn must reflect the sky. For this painting, I wanted a big sea and a stormy effect, so the sky had to be ominous. To get that effect, I painted a light cerulean blue sky into very wet paper at first. Then, while it was still wet, I laid in the clouds with ultramarine blue and a touch of alizarin crimson. As the water dried and the clouds began to fade, I darkened their upper portions with pure ultramarine blue. I tilted the block very little, so the sky here hasn't dripped much.

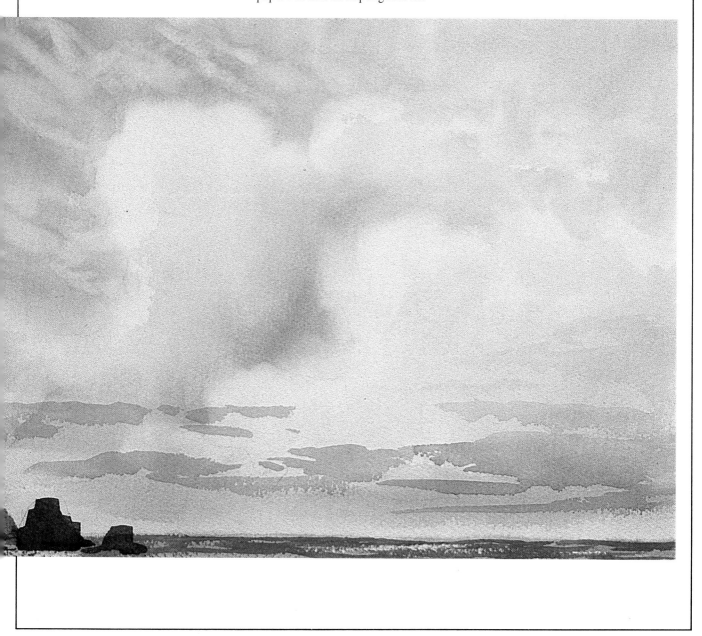

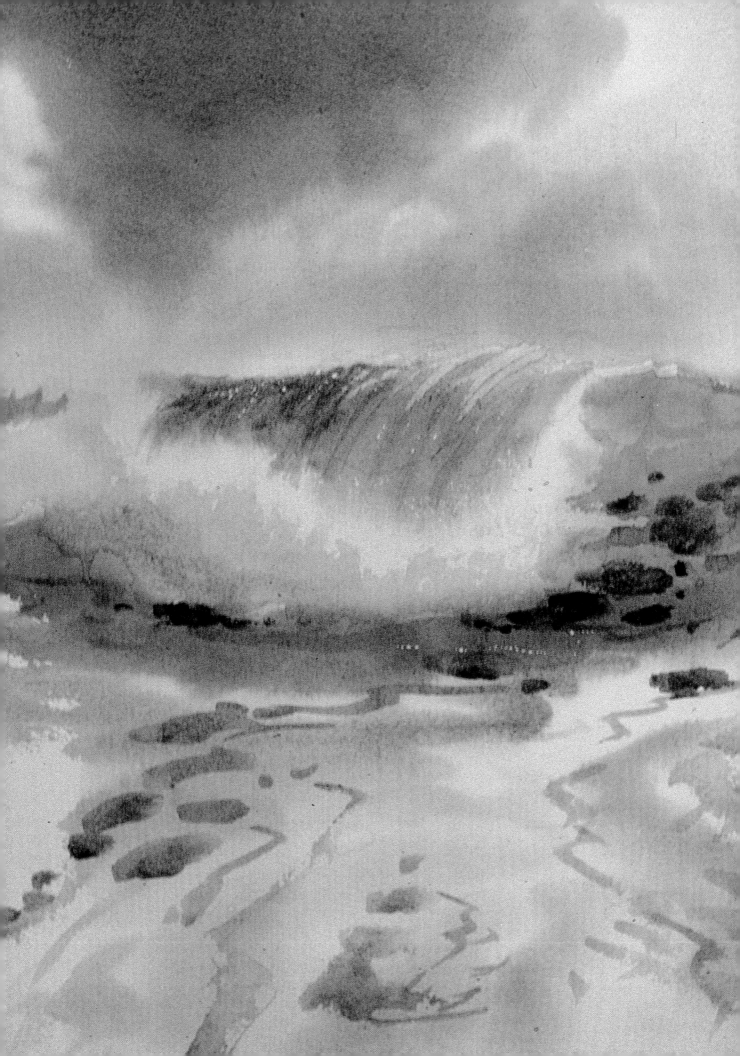

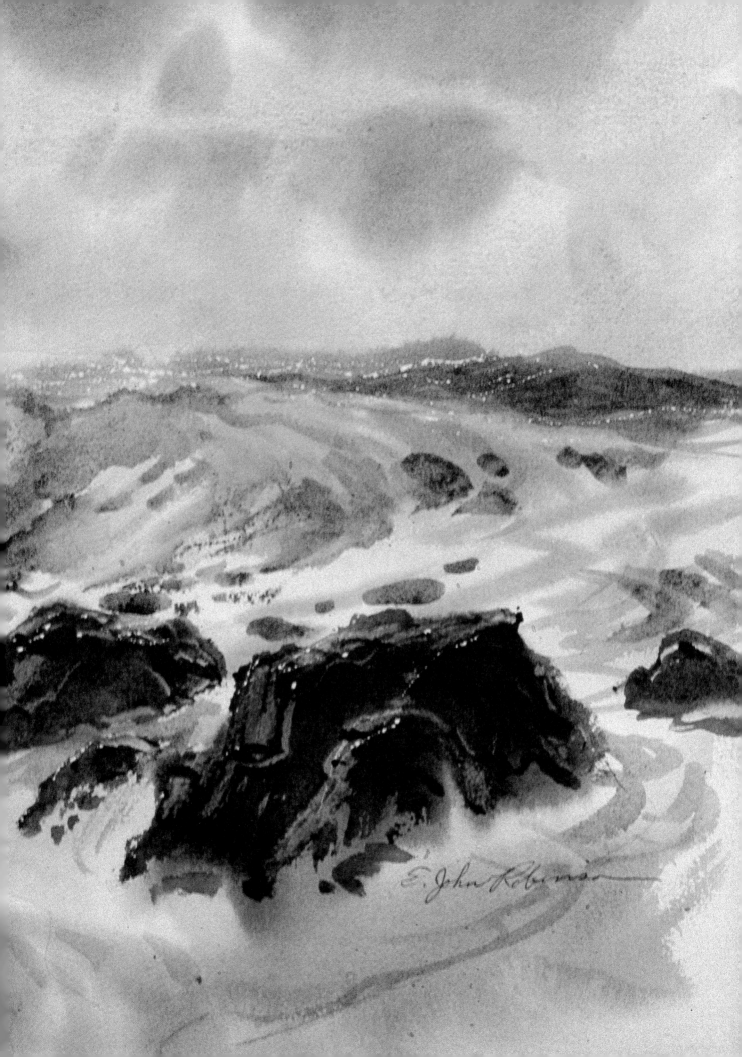
E. John Robinson

Beaches

Like rocks and headlands, beaches represent the element earth. But while rocks and headlands are symbolic of the struggle between land and sea, beaches—the remains of rocks and headlands—are the results of that struggle. Since beaches are moved at will by the sea, feel free to arrange them in any composition that suits your theme.

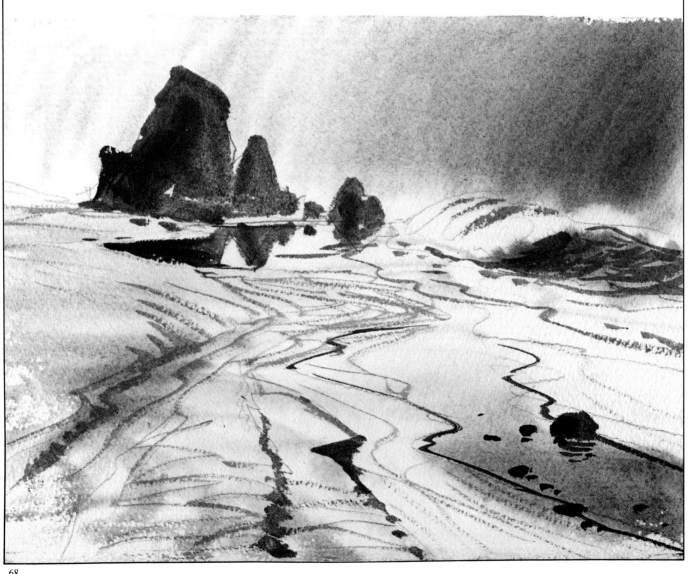

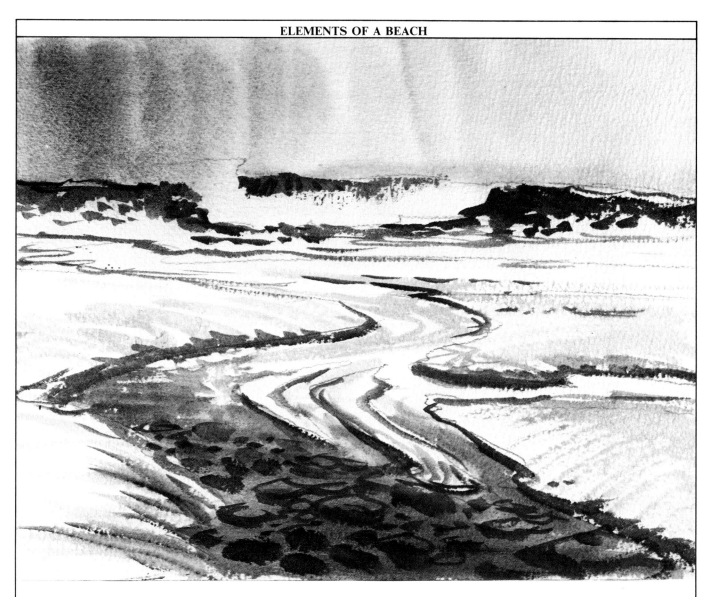

Beach with a Creek Outlet. If a beach is totally uninteresting and it takes up a good part of the composition, you can divide it into different segments. In this illustration I have broken up the beach with a creek outlet. When you do this in one of your paintings, it is best to place the creek in such a way that the areas on each side are of different sizes as well as different shapes. Never divide the area in half and never divide it with a straight line.

The shape of the creek should reflect the mood of the painting. If your theme is strong action, you can create a creek that zigzags with sharp angles. On the other hand, if you are illustrating a calmer moment, such as the one shown here, your creek may be lazy and meandering because the sea itself is quiet. Of course, in either case, the creek provides an excellent lead-in to a focal point.

Beach with Rocks (opposite page). In this illustration, I have featured a beach. That is, I have given more paper to it than anything else. However it is still not the focal point of the painting. As you can see, the curving wash line of the sand leads the eye to the rock, then to its reflection, and then to the wave. The point is this: Beaches are rarely the center of interest of a painting, but they can break up space in the composition and be arranged to lead the eye to some other reward.

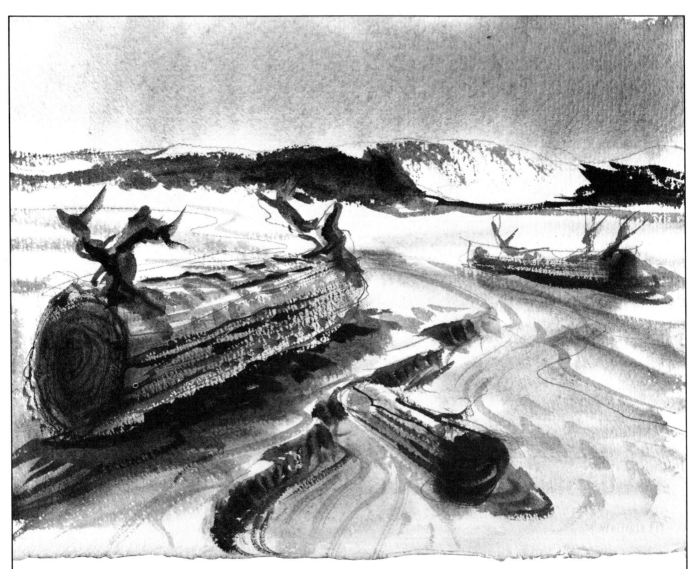

Beach with Driftwood. Another
way to break up the monotony of un-
interesting beaches is to add driftwood,
logs, and roots that wash ashore. When
adding driftwood, if you want the center
of interest to be the sea, you must be
careful that the driftwood doesn't be-
come too interesting. In this case I have
let the logs point to the breaker, which is
the center of interest. Notice that I use
three logs of different sizes and angles.
To avoid repetition, which is distracting,
don't allow the logs to point in the same
direction. Also don't allow them all to be
the same size. In addition to aiming the
logs, you can see that I made a curving
line in the sand, too.

 When the foreground is as busy as this,
it is best to have a quiet sky. The sea
would be lost if the sky were as broken
up as the foreground.

The Wet-Sand Effect (below). The wet sand is what I call the "slick." It is the area that the waves wash upon so frequently that it never has a chance to dry out. The slick is especially effective in a seascape with a beach because wet sand can reflect like a tide pool. But with the slick, a larger area can be used for reflections.

In this illustration, I have focused attention on the end of the breaker by contrasting the white water against the dark of a rock and its reflection in the slick. The beach and the incoming foam both lead the eye to the focal point. Notice that small rocks as well as headlands and sky reflect in the slick. The slick has also helped to break up a rather large area of the foreground.

Keep in mind that beaches are an intimate part of seascape, but even if they are not the featured subject, they can be used to support one that is. I will also show you how to paint a beach step-by-step in color later.

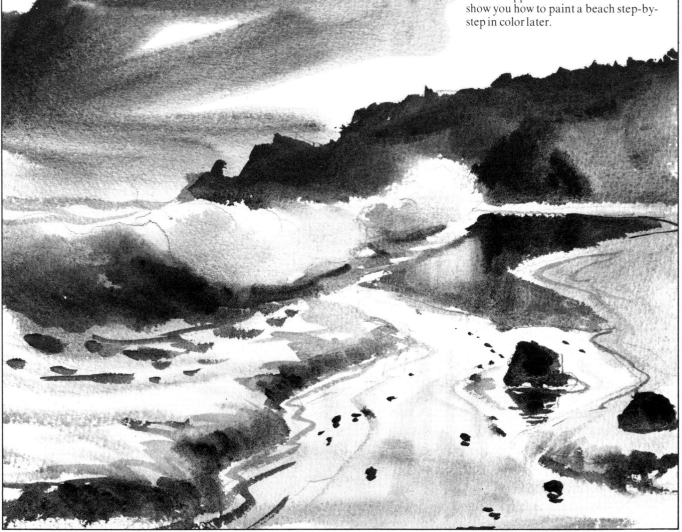

1. I am making this lesson a bit more advanced by including a creek outlet and a group of rocks with the beach. After all, a beach without something of interest is hardly worth painting. The first order of business is to decide the color of the sky, because it reflects in the creek water. I choose ultramarine blue for this. Now I draw the position of the creek and rocks and wet the paper with a 2″ (50mm) flat brush. Dipping a 1″ (25mm) flat sable brush into ultramarine blue, I then paint the reflected area of the creek. Starting at the bottom and working upward, I let the paint thin out so the color lightens as it nears the shoreline. With light ultramarine blue, I paint a horizontal stroke across the sky and let it run downward. I also paint a light stroke or two in front of the spot where I will place the major wave. This dark area will later become a shadow.

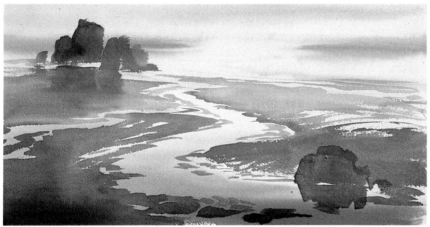

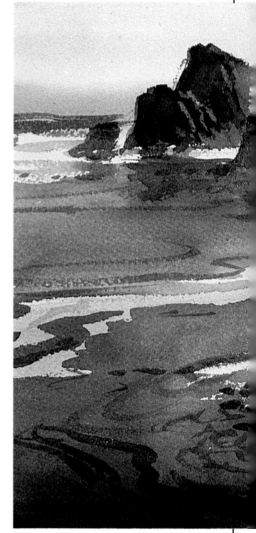

2. For this step I want the paper dry and my brush wet. I use a ½″ (13mm) flat sable brush and pure raw sienna, with enough water to make the color lighter than the tube color. Now I paint the entire beach area, being careful to leave clean edges along the creek and secondary outlets. Then, while the paint is still wet, I add ultramarine blue and a touch of burnt umber to the foreground to darken the beach. With this same mixture, I add the rocks. At this point I also add the reflection of the foreground rock and a few extra lumps of sand in the creek bed.

3. In the final stage, I add a distant ocean, rock shadows, and textures. Starting with the ocean, because it is so far back, I whip in a few background swells and a breaking wave. I use my no. 12 round sable and viridian with a touch of ultramarine blue and leave the foam area unpainted. Then I shadow the rocks with burnt umber and a touch of ultramarine blue, both in the background and foreground, making those in the background a bit lighter because of their distance. With the tip of the no. 12 round and add-ing more water to the umber, I paint ripple lines in the sand, making sure they are not too dark. They can be used to show the contours of the sand as well as a shadow line along the creek edge. Finally, I top off the painting with a few nicks of my knife to add sparkle. Notice, even though the sea is distant and rather insignificant, it is still the center of interest. The creek and the ripple marks lead the eye to the ocean. The distant rocks also stop the eye at that point; there is no interest beyond it.

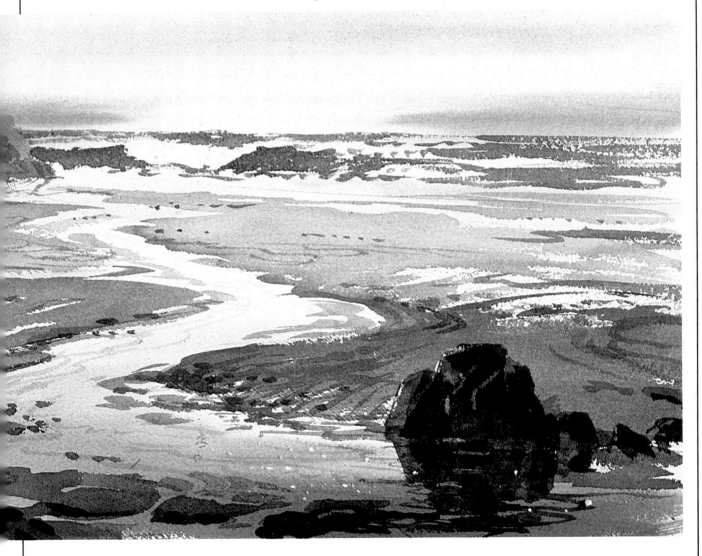

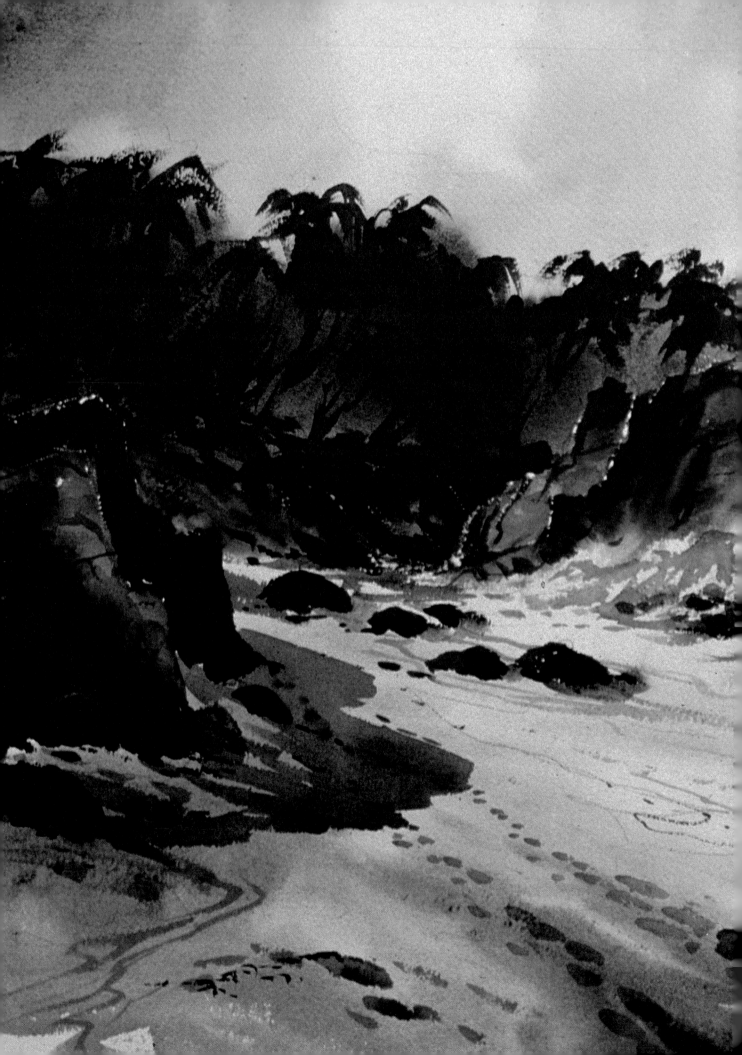

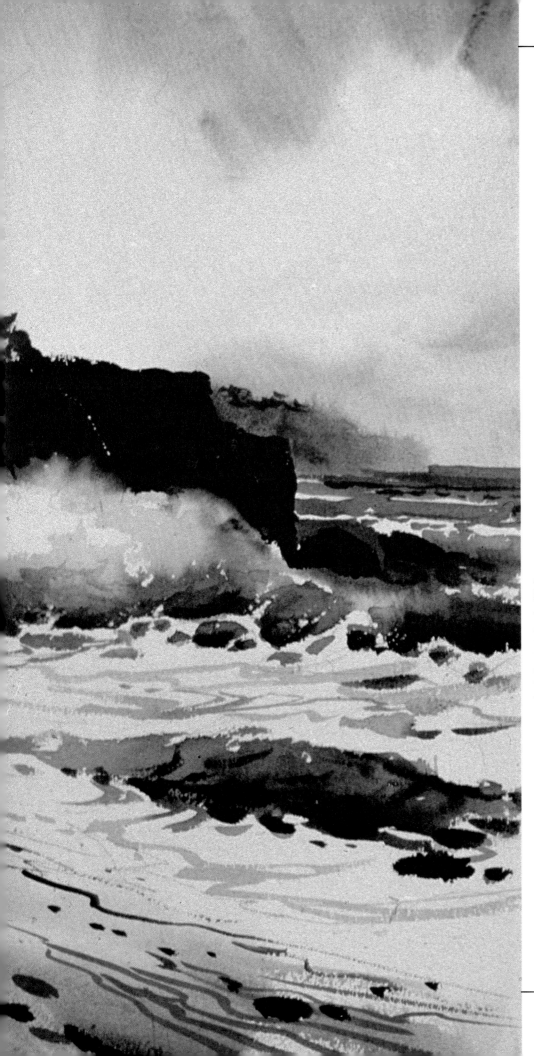

Waimea Beach, Oahu,
18"x22" (46 x 56 cm),
Arches 300-lb rag
paper, rough.

The beach takes up quite a bit of the composition in this painting but it is obviously not the main feature. It does, however, lead the eye in several ways to the ocean, which is the center of interest. In the first place, the shape of the beach is pointed toward the major wave. The eye would go on, but it is stopped by the rock shadow cast on the left. The textures on the sand—the footprints, and wash marks, and ripples—follow the contour of the beach and lead the eye to the water. Finally, the colors of the beach and its variations in values also lead to the sea. For example, in the foreground, the sand is darker and the raw sienna I used is strongest. As the beach reaches the water, the sand is lighter and the color less intense. Such gradations of color and value also lead the eye because the eye follows changes.

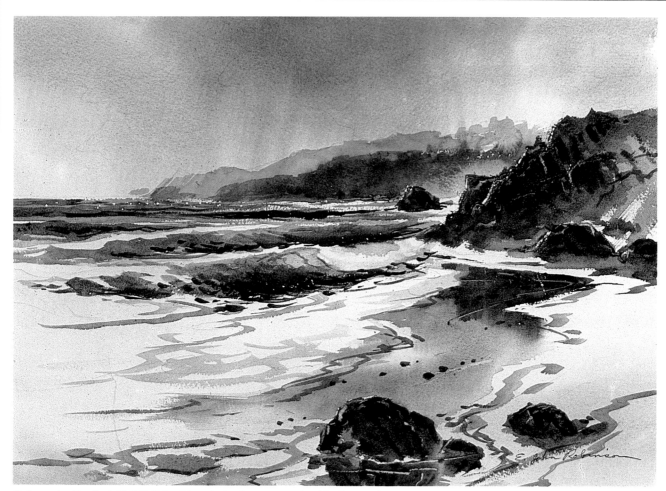

Rain to the North, 14″x20″ (36 x 51 cm), Arches watercolor block, rough.

Here is an example of a middle-value
painting with a strong light area and a
punch of dark. The center of interest is
the point where the wave meets the large
rocks. The dark reflection and rock pro-
vide the contrast to the foam and the
light sand. The wet sand or "slick" leads
the eye to the focal point. The slick gets
its color from the sky and rocks. This is a
good way to harmonize the sky and the
foreground.

Part Two

PUTTING IT ALL TOGETHER

New England Coastline

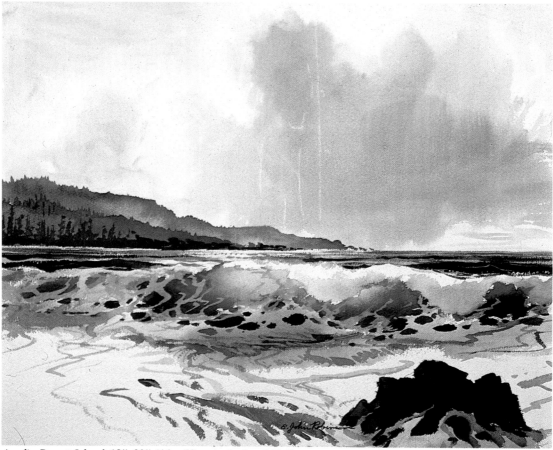

Acadia Desert Island, 18"x23" (46 x 58 cm), Arches 300-lb rag paper, rough.

The water in the Pacific is no different from the water in the Atlantic because it is the makeup of the shoreline, not the water itself, that creates differences from one coast to the other. For example, from coast to coast, rocks vary in shape and color, sand grains differ in color and size, and there are numerous species (and therefore different colors) of seaweed. The topography of beaches differs as well, causing some waves to crash against bluffs in deep water while forcing other waves to collapse lazily against gently sloping shores.

On the rugged shoreline of northern California and Oregon, huge waves hammering against rocky bluffs are a common sight and have influenced my paintings.

Although I am well aware that Atlantic storms can produce gigantic waves and frothy surfs, after a recent trip to the New England coast, I decided to re-create what I saw under less-active circumstances. There I found a shoreline much different from the one I knew in the West. The distant water of the Atlantic was darker and a grayer blue than the waters I knew in the Pacific, and I felt that it reflected great depths. Closer to shore, I found the breakers to be influenced by the earthy color of the rocks, which ranged from a pale ochre through red ochre to a warm burnt umber. The colors of the shoreline trees and bluffs are also reflected in the surface of the ocean, and so they influence the colors of

the water—as well as the overall tonality of the painting. Here again there were differences between the coasts. The headlands in the East are frequently covered by deciduous trees while west-coast headlands usually have evergreens, if any trees at all.

In this chapter, I plan to show you the effects these local elements have on the water. I also intend to concentrate on two types of waves: a modest wave with some foam patterns on it and a collapsed wave moving up a rocky inlet. Though either of these waves could be found anywhere, I will show you how they, too, have been localized and individualized by their surroundings.

1. I first draw the simple outline of the wave I want, then add a few lines to show how much foam I expect to show. Notice that there are two kinds of foam to be painted: foam patterns on the face of the wave and breaker foam. The breaker foam is created by the leading edge of the wave flying apart as it falls (breaks) forward. The wind as well as the forward movement of the wave causes the breaker foam to spray backward.

In order for the foam to show up well, there must be contrast. I have indicated an area of sky behind the wave that I will make dark to provide contrast for the white foam. Notice that the curve of the cloud is in harmony with the curve of the wave foam—a small detail but one important to the overall feeling of movement in a composition.

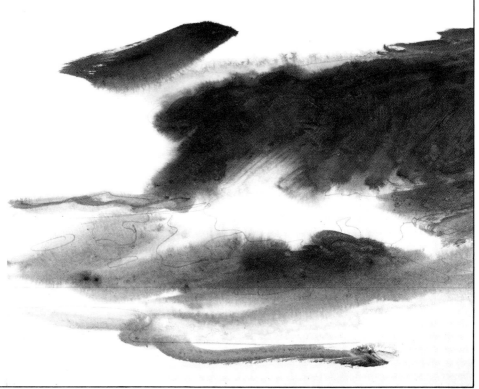

2. I begin by wetting the paper with a sponge. Next I mix cerulean blue and a touch of raw umber into water, making a dark mixture. While the paper is still wet, I apply the paint with a 1″ (25mm) flat brush. I work on the sky first, letting the dark cloud come right down to the top edge of the wave. Then, with a dry sponge, I wipe out the area of foam that extends into the sky. Finally, I brush in the background and the shadow beneath the foam with the same brush. I make the shadow lighter than the background by adding more water to the mixture.

3. In this final step, I use a no. 10 round sable brush. I first mix a dark ultramarine blue by adding a touch of raw umber and very little water to it and paint in the background swells. Next, for the wave, I mix Hooker's green with ultramarine blue. Starting at the bottom of the wave with the darkest color, I work upward. As I near the top of the wave, I add more water. This lightens the paint and helps show the transparent effect of the water. Notice that I have punched holes on the foam. They are different in size, as they are in nature, and the way they lie shows whether they are flat on the bottom or angled to climb up the face of the wave.

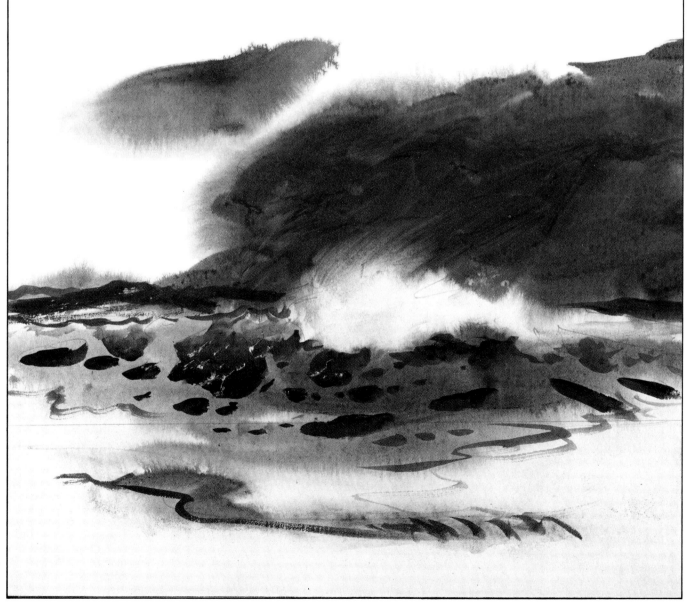

1. A collapsed wave is a breaking wave that has fallen or flattened on itself. It is not just a pile of foam, however. Remnants of the former wave are still visible. In this outline, notice that I have shown the irregular edge of what had once been the wave as it rolled forward onto itself. In front of that is the mass of foam created by the spill. The roller portion of the wave is irregular because the leading edge was choppy before it peeled over.

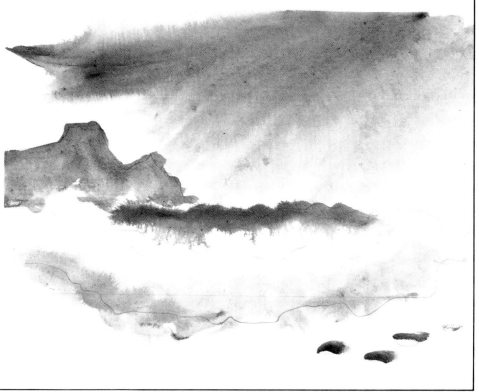

2. After wetting the paper with the sponge, I prepare a light mixture of ultramarine blue with a touch of yellow ochre, with a lot of water to lighten it. Then, with a 1″ (25mm) flat sable brush, I paint the sky area. I start at the top with the darkest of the mix and, as I work downward, the wet paper lightens the color. At this point, I also paint the shadow beneath the foam mass.

With the same brush and raw umber I next paint the background rock on the slightly damp paper. Then I mix a new color—ultramarine blue and viridian—for the edge of the roll. I re-wet the lower portion of the roll, then apply the green color with a no. 10 round sable brush. The top edge is slightly fuzzy, but the lower portion runs downward toward the foam, showing the movement of falling water.

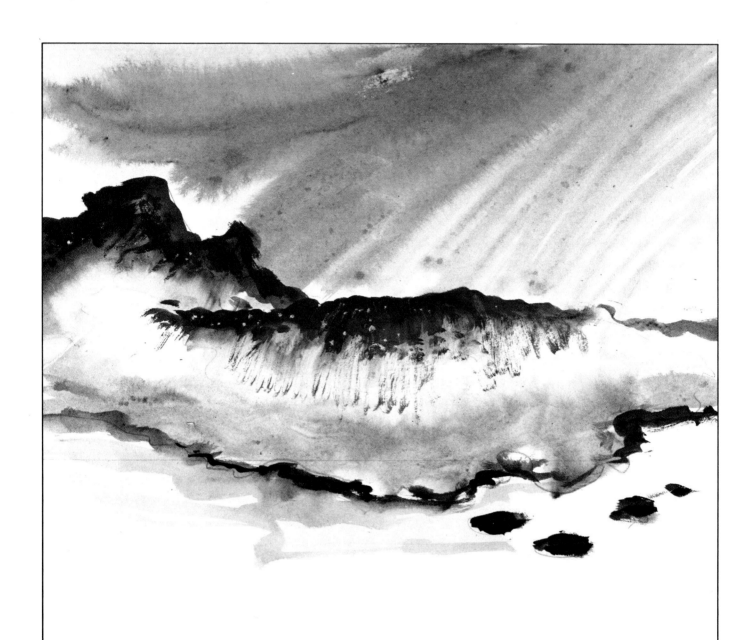

3. To complete the wave, I darken portions of the rock with a mixture of ultramarine blue and raw umber and sponge out the foam that is in front of the rock. Then, with a darker mixture of ultramarine blue and viridian and a no. 10 round sable brush, I re-paint the roller edge of the wave and dry-brush more streaks falling toward the mass of foam. Finally, I lay in a darker shadow underneath the foam mass with the tip of a no. 10 round sable brush and the same blue-green mixture I used on the roller edge of the wave.

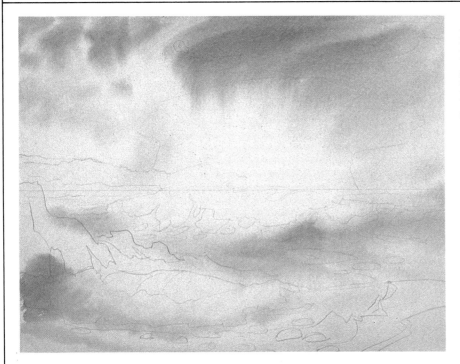

1. I begin my painting of the New England coast with a light pencil drawing. I keep it as simple as possible. Then I wet the entire paper thoroughly with a sponge. I next mix the sky colors—cerulean blue with a touch of mauve. Then while the paper is still very wet, I quickly stroke on the color, then tilt the board to let the paint run. If some of the sky color runs into the sea area, I leave it. But I sponge up any color that covers the foam area. When the color has run enough to suit me, I straighten out the board and apply the same color to the shadow at the base of the wave and under the foreground rock.

2. After making certain the paint is completely dry, I re-wet the sky area. Switching my paint mixture from cerulean to ultramarine blue and a touch of mauve, and with the same brush, I paint the second set of clouds. I make them darker than the first group and place them directly behind what will be the breaker foam. After the paper has dried a bit, I use the same mixture to work in a few background swells.

While the rest of the paper is drying, I work on the foreground rocks and beach. With a ¾″ (19mm) flat sable brush and raw sienna, I paint in the pebbles, boulders, and the major rocks on the beach. I make them a medium shade of sienna so I can overpaint the shadows later.

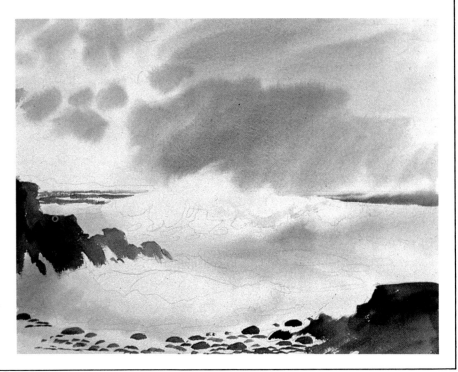

3. Now I paint the headland a combination of cerulean blue and viridian with a patch of yellow ochre for color. Notice that I also reflect these colors onto the sea. I now begin the major wave. For this I use a no. 12 round sable brush and watered-down paint on dry paper. As in the demonstration of breaker foam, I begin at the bottom of the wave with the darkest shade of the mixture, a combination of viridian and a touch of ultramarine blue. As I work upward on the face of the wave, I lighten the mixture by adding more and more water until the top portion is nearly white. Then, with the same mixture, I punch dark holes in the mass surface foam, and work long lines of it into the foam until it trails into clear water. I also paint a few broad lines of shadow into the surf to show the movement of the foam.

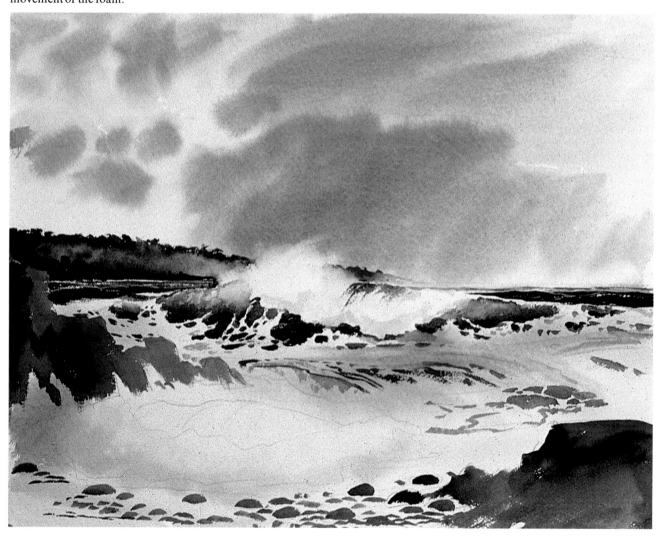

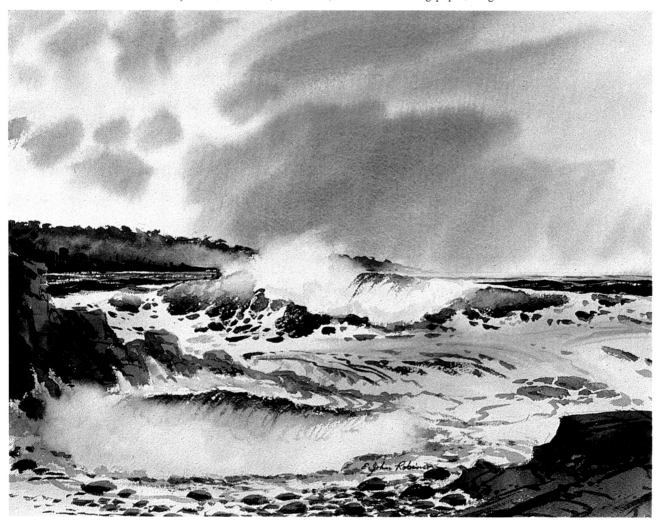

Gully Point, 18″x22″ (46 x 56 cm), 300-lb Arches rag paper, rough.

4. In this final step, I begin by painting the collapsed wave in the foreground as I did in the demonstration earlier. I re-wet the upper roll area of the paper and apply the paint—a mixture of viridian with a touch of ultramarine blue—with a no. 12 round sable brush. It runs forward to the foam and I sponge up any paint that would cover the foam. After this has dried a bit, I darken the leading edge of the roll and increase the shadow under the foam. I use the same blue-green color as before.

To darken the rocks, I use a ½″ (13mm) flat sable brush and burnt umber with a touch of ochre. I do not re-wet the paper because I want to keep the texture derived earlier from drybrushing. Notice that I merely suggest cracks and crevices with a slightly darker paint, mostly burnt umber. I also use this umber to shadow the foreground pebbles and rocks.

This final step has pulled together all the elements that I believe show this to be a unique scene from a specific area.

Storm Water

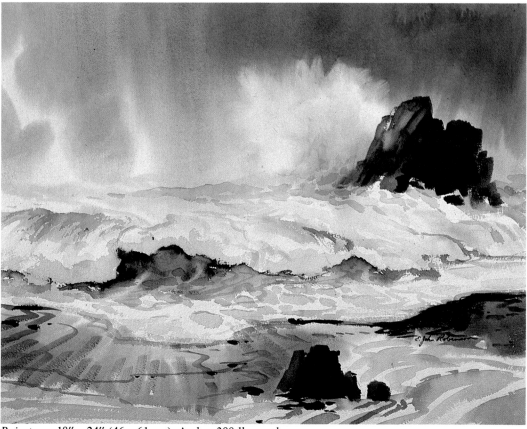

Rainstorm, 18″ x 24″ (46 x 61 cm), Arches 300-lb rough paper.

If anything had led me into seascape painting, it was the awesome beauty of the sea in a storm. Where I grew up, along the Oregon coast, the sea was a respected neighbor. Many of our family took their living from the sea and some gave their lives to it too. The winter waves in particular were respected both for their unique beauty and their destructive force. My early years brought me a wealth of impressions, but none so lasting as the coastal storms.

To this day, if someone asks what I most enjoy painting, I would readily reply, "The storms—the big, action." I realize some people are put off or perhaps frightened by the force of the sea. But for me, and fortunately for many others, the stormy sea is a superb example of the power of nature, a power altogether both overwhelming and quite beautiful.

But I must point out that "stormy" does not necessarily mean "angry."

Many of the big waves are the result of a storm that has either gone or is too far off to be seen and they reach shore in full sunlight. These are my favorites. These high waves take on an almost happy mood and I paint them in strong light and shadow. Rather than finding them depressing, I see their mood as one of frolic, as forms vital with energy. It all depends on your point of view.

I described the energy that creates the waves in Chapter 2, but not the results. The larger and more violent the storms that give birth to the waves, the larger their offspring. These storms create swells larger than normal that crash as large breakers when they reach shore.

If the storm takes place near land, then the distance between waves will be shorter as well. If the distance between waves gets too close, the foam from the first breaker has no time to dissipate before the next wave

breaks and churns the water some more. So the result is a mass of foam, sometimes several inches thick with only a few holes in it revealing the water below.

When this occurs, the air becomes filled with moisture and visibility is cut to only a few yards. If the waves are crashing against rocky cliffs as well as breaking upon each other, the noise can be deafening. Then the very air is charged with the energy that only nature can create. We artists can only attempt to capture a small part of it.

In this chapter I will demonstrate how I paint "the big ones," the rising action of large storm waves. I will also give you lessons on painting patterns in mass foam, the surface froth that is often so difficult to portray. In each case, I will be painting that part of the sea I cherish most, the active, vital energy that first inspired me to paint!

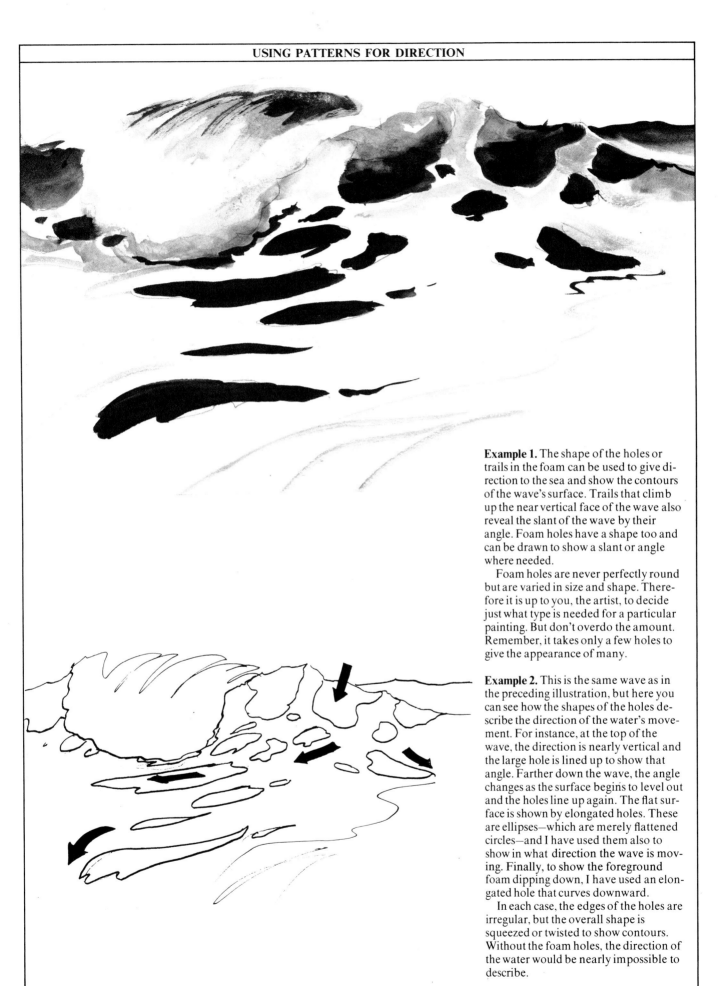

Example 1. The shape of the holes or trails in the foam can be used to give direction to the sea and show the contours of the wave's surface. Trails that climb up the near vertical face of the wave also reveal the slant of the wave by their angle. Foam holes have a shape too and can be drawn to show a slant or angle where needed.

Foam holes are never perfectly round but are varied in size and shape. Therefore it is up to you, the artist, to decide just what type is needed for a particular painting. But don't overdo the amount. Remember, it takes only a few holes to give the appearance of many.

Example 2. This is the same wave as in the preceding illustration, but here you can see how the shapes of the holes describe the direction of the water's movement. For instance, at the top of the wave, the direction is nearly vertical and the large hole is lined up to show that angle. Farther down the wave, the angle changes as the surface begins to level out and the holes line up again. The flat surface is shown by elongated holes. These are ellipses—which are merely flattened circles—and I have used them also to show in what direction the wave is moving. Finally, to show the foreground foam dipping down, I have used an elongated hole that curves downward.

In each case, the edges of the holes are irregular, but the overall shape is squeezed or twisted to show contours. Without the foam holes, the direction of the water would be nearly impossible to describe.

1. When the surface is frothy with foam, a new wave moving in will lift the surface, thinning the foam and causing it to split apart. The thinnest areas become trails or lines of foam, while the thicker areas become merely a patchwork of holes.

In this step, I draw a wave beginning to break and show the outer edges of the surface foam that has been split off by the rising of the wave. Notice how the edges indicate the trails and the holes near the edges reveal that the foam is quite thin. .

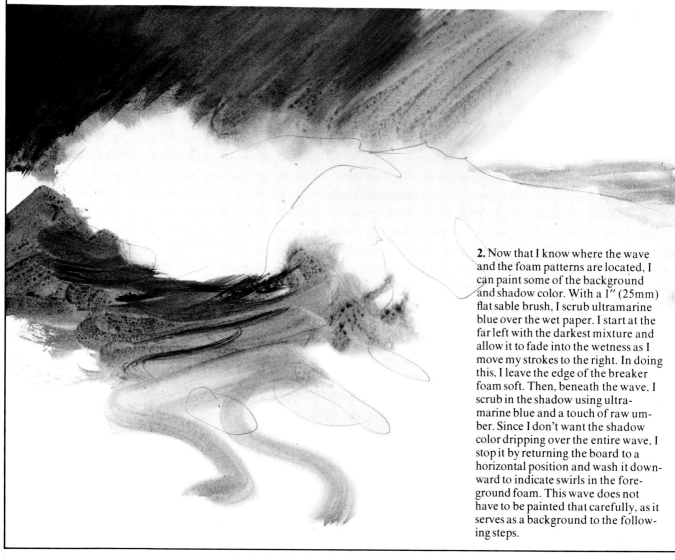

2. Now that I know where the wave and the foam patterns are located, I can paint some of the background and shadow color. With a 1″ (25mm) flat sable brush, I scrub ultramarine blue over the wet paper. I start at the far left with the darkest mixture and allow it to fade into the wetness as I move my strokes to the right. In doing this, I leave the edge of the breaker foam soft. Then, beneath the wave, I scrub in the shadow using ultramarine blue and a touch of raw umber. Since I don't want the shadow color dripping over the entire wave, I stop it by returning the board to a horizontal position and wash it downward to indicate swirls in the foreground foam. This wave does not have to be painted that carefully, as it serves as a background to the following steps.

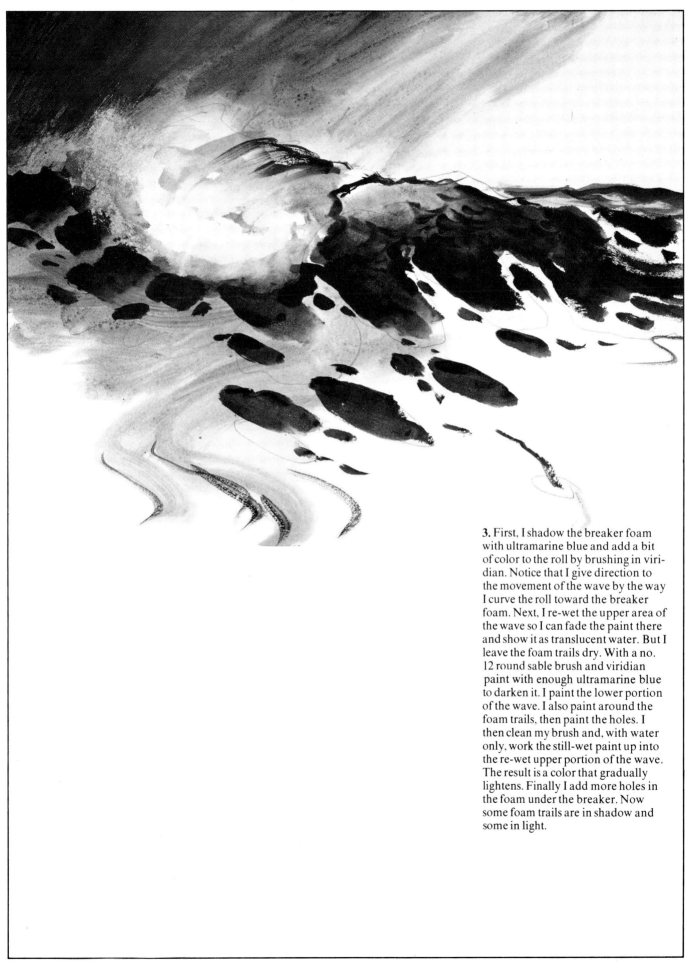

3. First, I shadow the breaker foam with ultramarine blue and add a bit of color to the roll by brushing in viridian. Notice that I give direction to the movement of the wave by the way I curve the roll toward the breaker foam. Next, I re-wet the upper area of the wave so I can fade the paint there and show it as translucent water. But I leave the foam trails dry. With a no. 12 round sable brush and viridian paint with enough ultramarine blue to darken it. I paint the lower portion of the wave. I also paint around the foam trails, then paint the holes. I then clean my brush and, with water only, work the still-wet paint up into the re-wet upper portion of the wave. The result is a color that gradually lightens. Finally I add more holes in the foam under the breaker. Now some foam trails are in shadow and some in light.

Linear Composition. This rough outline shows the positions of the main actors of this drama—the waves and the rock. I plan to paint a large storm wave in the process of breaking, backed up by another wave looming in the background. Both waves will be met by the hard solidity of a rock. I have selected an angle of view above the scene and have chosen to make the composition vertical so that nothing on either side can distract from this drama.

Value Composition. Just as I have kept the linear composition simple, I have also done the same with the value composition. As I said before, the main actors in my drama are the waves and rocks. Everything else is secondary. That is why I have chosen to give the greatest strength to the major wave. It is the darkest area and is placed against the lightest area for the strongest contrast. The background wave is waiting in the shadows.

The foreground rock takes second billing, lacking the spotlight that is on the breaker. But its color will make it special. If it attracts attention, the line of foam patterns will lead the eye back to the breaker, the star of the show.

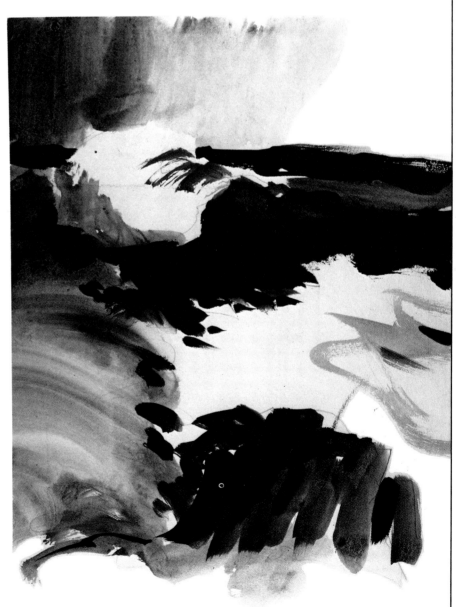

1. After pencilling in the composition with the fewest lines possible, I wet the paper with a sponge. I use a fair amount of water and tilt the board slightly downward so I can start at the top and work my way down without the lower sections drying out too soon.

With a 1″ (25mm) flat sable brush and a mixture of cerulean blue and Davy's gray, I begin the sky. (If you do not have Davy's gray, a touch of raw sienna will take the edge off the blue.) Starting in the left-hand corner, I quickly whip the brush in vertical strokes as I move to the right. I allow the color to fade out a little past the middle of the paper.

Now I paint the shadows on the water in the same manner. Working the sky color downward on the left-hand side, I start with the darkest mixture and allow it to fade somewhat as I proceed. In this case I use horizontal and slightly curved strokes to give a humped shape to the foreground. Then, adding a bit more cerulean blue to the mixture, I make a few strokes where the water spills from the rock and add a few faded patches of shadow slanting down on the right-hand side. I have now painted the sky, the shadow beneath the wave, and most of the contours of the foreground.

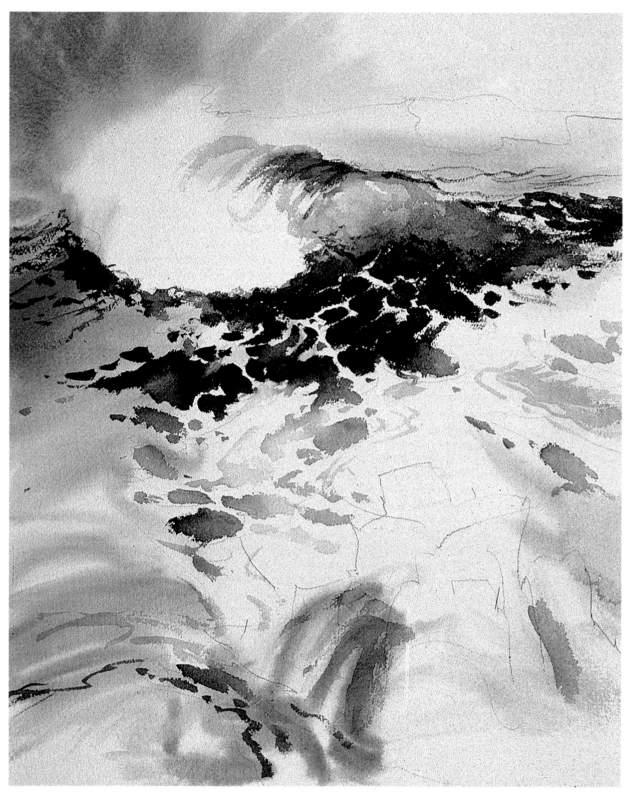

2. I allow the paper to dry completely, then re-wet only the top half the wave-face. Now I mix a bit of ultramarine blue into viridian green and paint the wave. As usual, I start at the base of the wave with the darkest paint and work upward. When I reach the re-wet area, I clean my brush and work upward from the painted area into the water, merely moving the existing paint so that it fades as it spreads upward. Then I return to the base of the wave and carefully paint the holes there, leaving some foam trails to climb up the wave face. I use a no. 12 round sable brush and the viridian mixture to paint the roll.

Painting downward from the wave, I thin the paint with water to lighten it as I paint the foam holes. The lighter color suggests that the water is mixed with foam below the surface, too. Notice the movement created by the angles of the holes.

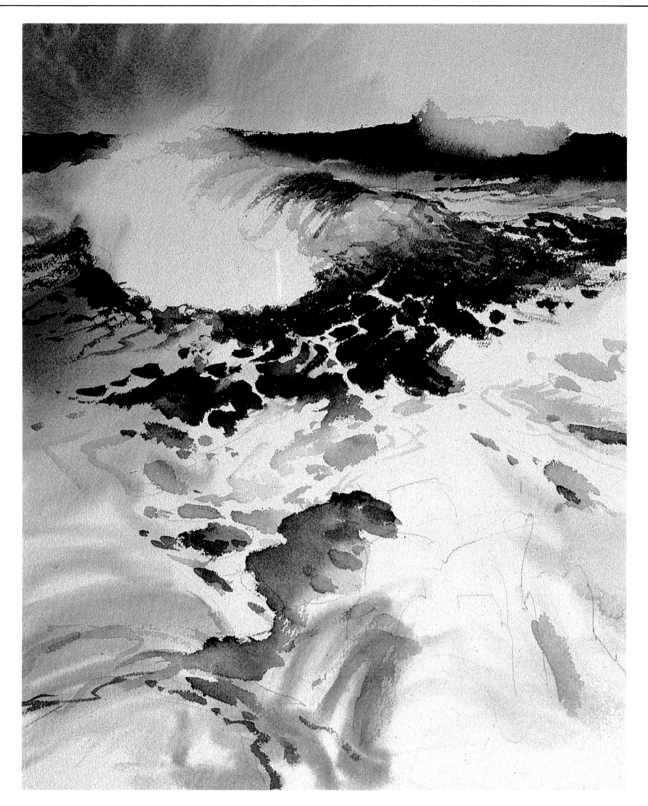

3. When the paint is dry, I notice the green has faded somewhat. So, with the point of a no. 8 sable brush, and the viridian and blue mixture of step 2, I work in ripples at the base of the wave, leaving the translucent area clear. Then I paint the background wave.

For the background wave I mix Prussian blue and viridian green because I want the wave to be very dark. When this is dry, I paint the foam with the same mixture, lightened with water.

Finally, for the cast shadow in the foreground, I use the same Prussian blue—but I add a touch of alizarin crimson to it because I want the foreground to appear warmer than the shadowed background. Again, I use a no. 8 round sable brush.

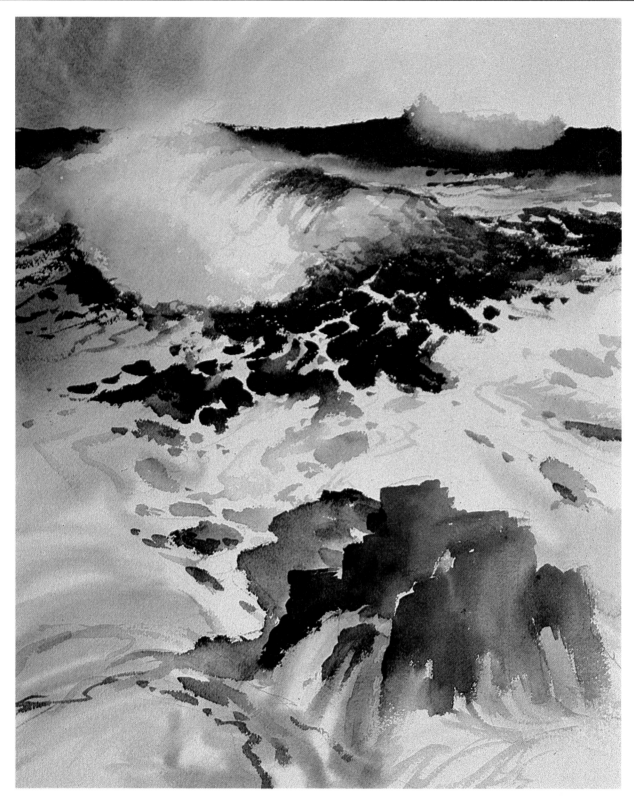

4. After making sure the paper is dry, with a no. 12 round sable brush and ultramarine blue with a tiny touch of alizarin crimson, I paint the shadow on the major breaker. Wetting the brush heavily I apply the paint to the base of the foam and work upward. At the top of the foam, where I want the edge to be soft, I use the side of the brush to gently scatter the paint over the surface of the paper.

Then I switch to a ½″ (13mm) flat brush to paint the base color of the rock. I mix raw sienna and mauve, and paint the rock with vertical strokes. I am careful to paint around the water spills and then leave hard edges at the top and soft edges at the bottom, where the rock sits in the foam. While the paint is still wet, I add Prussian blue to the shadow side, then blend it by brushing it into the sienna and mauve.

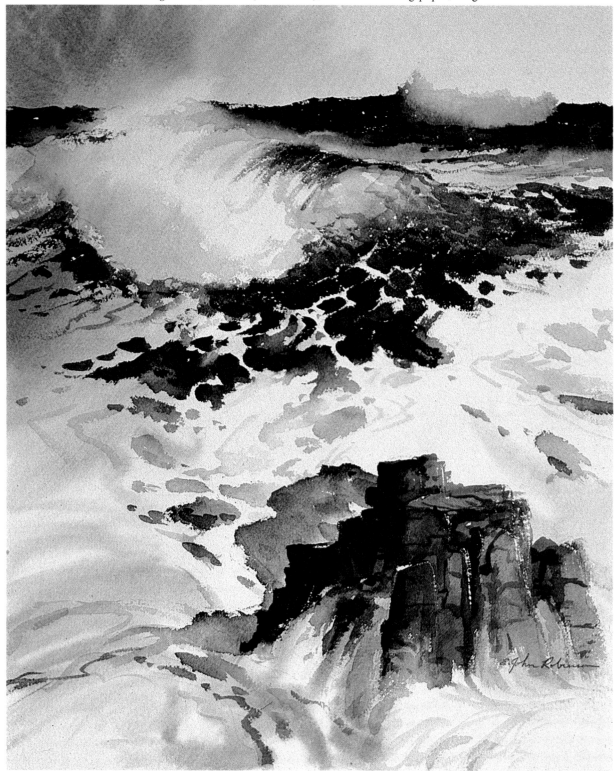

5. For this final step, I control my urge to add more detail to the wave and foam and concentrate only on the rock. To add more elsewhere would surely detract from the composition.

With a darker mixture of mauve and Prussian blue and a ½" (13mm) flat sable brush, I deepen the shadow on the rock.

Then I fade the mixture with water and texture the now-dry rock with light shadow lines painted over the raw sienna base. When this dries, I add thin cracks to the rock with burnt umber and the point of a no. 6 sable brush. Finally, I scratch a few sparkles into the wave face and into the right-hand side of the rock with the point of my knife.

I now consider the painting finished. It is a simple composition containing a major wave, a secondary wave, and a major rock—a two-against-one scenario of a powerful sea against the land. All else is kept minimal.

Tropical Waters

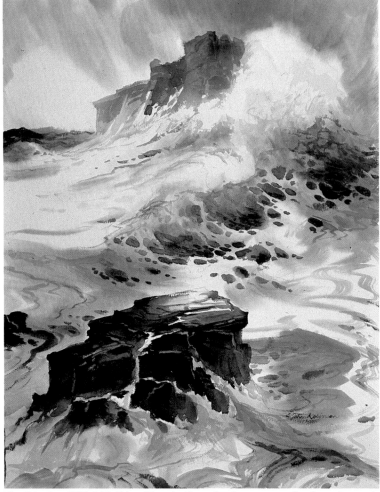

The Big Sea, 22″x26″ (56 x 66 cm), Grumbacher watercolor board, rough.

Most people think of the beaches of Hawaii or Mexico as paradises of warm water and warmer beaches, of swaying palms and gentle waves lapping at their feet. For the most part, they are right. But tropical lands can have tropical storms and extremes in weather just like any other coastal land.

While I enjoyed the balmy side of the Hawaiian weather, I was absolutely delighted to come upon a wild storm one day on the island of Maui. It was on the Keanae peninsula, off the road to Hana. There wasn't much wind that day, just enough to sway the palms and blow the spray. But the air was filled with the thunder of huge waves crashing against the rocks. And now and then an explo-

sion of water and foam would climb higher than the rest. Sometimes the foam burst even dwarfed a nearby tin-roofed shack. It was exciting enough to make any seascape artist stop and record it. I immediately took photographs and made sketches and it is from these notes that I will present the lessons of this chapter.

I hope to show how I paint palm trees, foam bursts, and water spilling from rocks, and capture the spirit of active water. The water in this case was so whipped up that it was almost entirely foam, with only a few spots of green water showing through. Quite a contrast to the quieter *Waimea Beach, Oahu* on page 74-75!

The Big Sea (above) shows action, backed by a strong, moving compo-

sition. I have featured a large storm wave as it powers its way between the rocks. Depending upon how you see it, the compositional lines form an angular "S" or "Z" curve.

I placed diagonal strokes in the sky to make it appear to be pressing downward as if helping to move the sea. The tilted angle and light color of the background rock shows it to be overwhelmed by the wave that has assaulted it. The foreground rocks are low, dripping wet, and completely at the mercy of the sea. The focal point here is the big foam burst at the edge of the rock. The foam patterns on the wave lead the eye to that point, as does the sky and the ripples in the foreground foam.

My version of palm trees is sketchy, but since I only use palms as background rather than subject, I don't need to know the details of their structure. I usually paint them first in a light tan and green, such as a diluted raw sienna and Hooker's green or viridian. Then I paint their trunks and fronds with a no. 6 round sable, working with a wet brush on the dry paper. When this is dry, I go over the areas with a darker version of the underpainting. Finally, with burnt umber, I underscore the shadows and texture the fronds, especially the dark areas under the foliage.

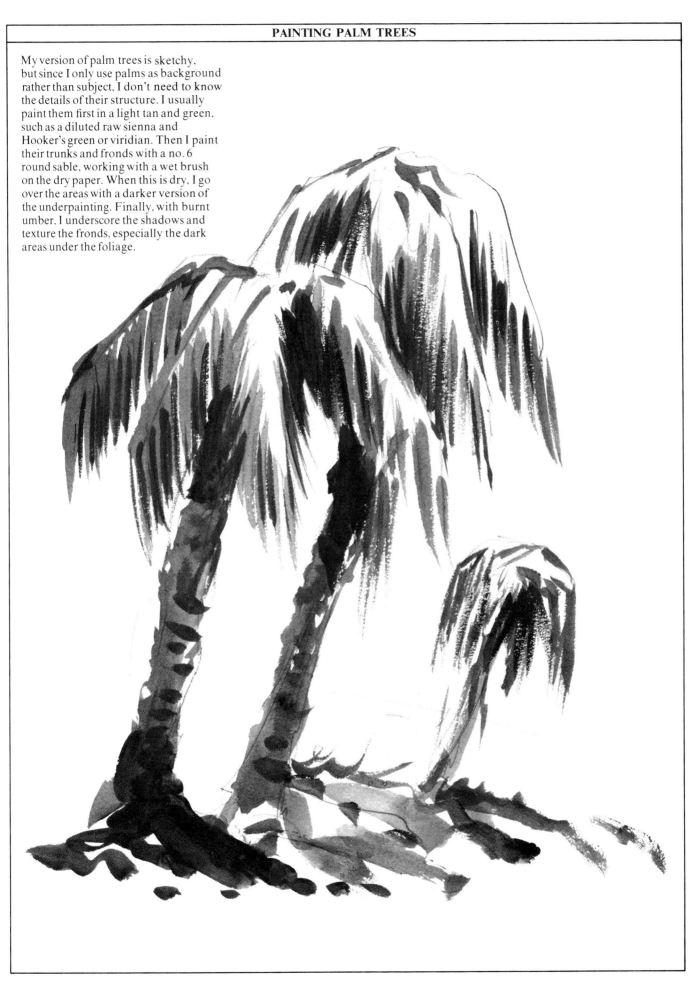

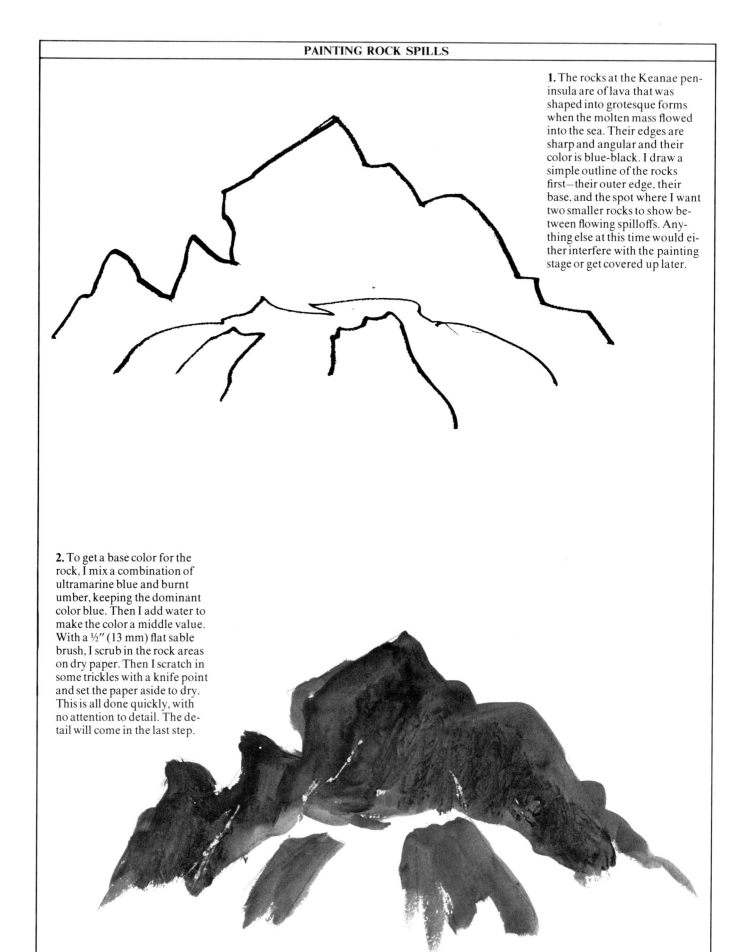

1. The rocks at the Keanae peninsula are of lava that was shaped into grotesque forms when the molten mass flowed into the sea. Their edges are sharp and angular and their color is blue-black. I draw a simple outline of the rocks first—their outer edge, their base, and the spot where I want two smaller rocks to show between flowing spilloffs. Anything else at this time would either interfere with the painting stage or get covered up later.

2. To get a base color for the rock, I mix a combination of ultramarine blue and burnt umber, keeping the dominant color blue. Then I add water to make the color a middle value. With a ½″ (13 mm) flat sable brush, I scrub in the rock areas on dry paper. Then I scratch in some trickles with a knife point and set the paper aside to dry. This is all done quickly, with no attention to detail. The detail will come in the last step.

3. Now that the base paint is dry, I can show interior shapes, textures, and shadows. I texture the rock with the same mixture of ultramarine blue and burnt umber, but with less water, which makes it darker. With a no. 6 round sable brush, I scrub in the shadowed side of the rock and indicate a few cracks and sharp edges. Then I add a few more knife scratches for a touch of sparkle.

Finally, I add the shadows in the water. I use a no. 6 round sable brush and work on dry paper. My colors are ultramarine blue and a touch of viridian, with enough water added to the paint to keep the shadow lighter than the rocks. Notice how some areas are left white, others shaded, and still others are streaked to show the movement of falling water. I never could have achieved this effect if the paper were wet.

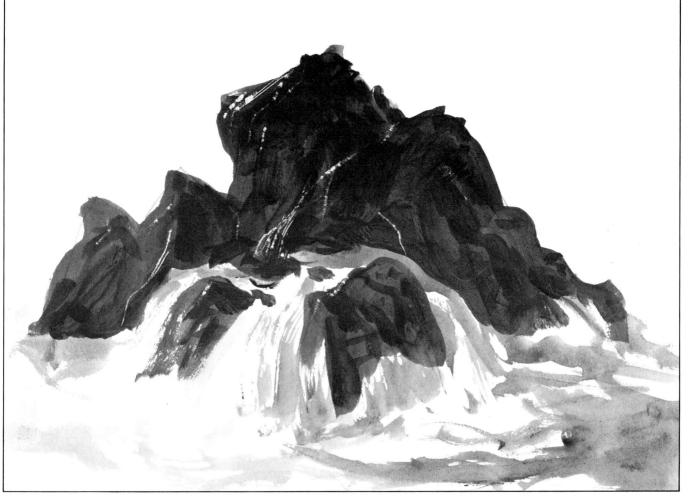

1. First I make a very quick outline of what I intend to show as water dashing against a rock. Notice the irregular shape of the foam burst against the angular shape of the rock. Whenever possible I try to show a contrast this way. The foam burst has no definite shape and is always in the process of changing. Its edges are soft and sometimes lost altogether. In contrast, a rock is hard-edged and solid, an unmovable object.

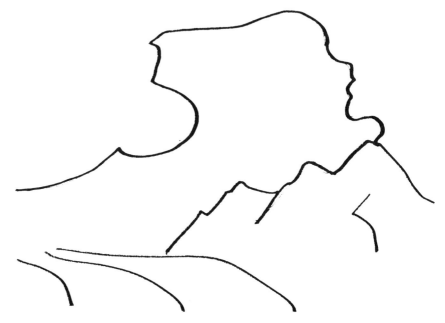

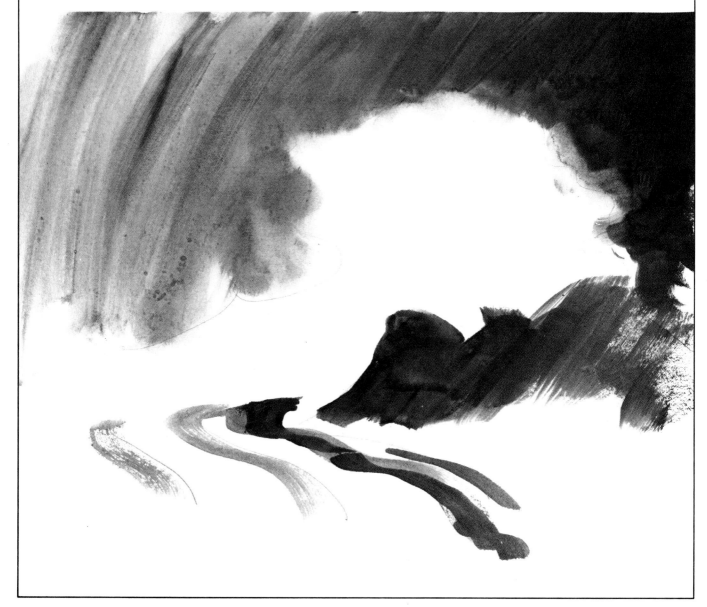

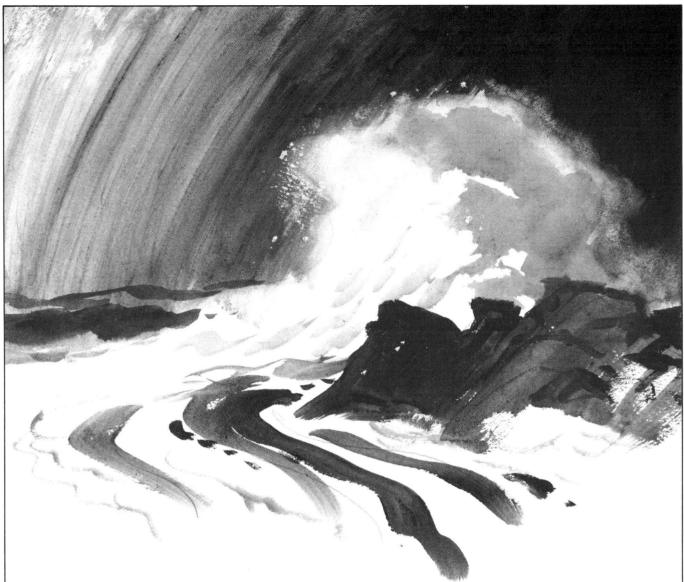

2. I dampened the paper with a sponge and let the water soak in a bit. Then, for the sky, I mix a touch of burnt umber with ultramarine blue. With a 1″ (25 mm) flat sable brush, I apply the darkest mixture of the blue on the right, behind the foam burst. I then paint the rest of the sky around it. As I work to the left, the paint becomes lighter because it is being absorbed and diluted by the wet paper. I then lift off some hard edges of the foam with a dry sponge.

I scrub in the rock area with a ½″ (13 mm) flat sable brush and a mixture of ultramarine blue and burnt umber. Notice that I start at the left with dark paint and allow it to lighten as I move to the right. This makes a nice contrast to the sky, which fades in the opposite direction.

3. After making sure the paper is completely dry, I paint the background swells using a no. 8 round sable brush and ultramarine blue with a touch of Hooker's green. Then with a diluted mixture of Hooker's green, I spot in the holes in the foam that showed the underlying water and add a few lines to the foreground. In every case, the lines and spots show the direction of the movement of the water.

I then shadowed the foam burst with a weak solution of ultramarine blue and a touch of Hooker's green. As you can see, the rock has only a few textural lines and spots of dark umber, but both the rock and foam burst have been nicked with a knife point to create sparkles. The final result is sketchy, but the instructions are basic for painting any foam burst.

1. I begin by making a light pencil outline of the scene. I don't put in detail; that will come later. Then, I wet the paper thoroughly with a sponge and allow it to soak in. With a 1″ (25 mm) flat sable brush, I mix manganese blue and mauve with plenty of water and brush it into the wet paper.

This is only an underpainting, so I am not concerned with edges. I scrub in a background color for the sky, the shadow of the large burst, the distant lava rocks, and the shadow side of the foreground rocks and spills. While the paper is still wet, I move the edge of my sponge over the area of spilling water, lifting out the color and leaving the white paper.

2. If the paper is dry, I must now re-wet it for this step. With a 1″ (25 mm) flat sable brush and a darker mixture of manganese blue and mauve than in Step 1, I paint the dark clouds around the foam burst. I also underpaint the shack with the same color. As in the foam burst demonstration earlier, I use the sponge to soften the edges and prevent the sky color from running into the white foam. As the paper dries, I paint a few spots of green water near the foam burst and under the rock with a no. 6 round sable and Hooker's green. The paper is dry enough so that the spots of color don't run. Finally, with the paper even drier, I underpaint the rocks with a mixure of ultramarine blue and a touch of burnt umber, applied with a 1″ (25 mm) flat sable brush.

3. As I explained earlier, I paint the background palm trees in two stages. In this case, I underpaint trunks and fronds with a mixture of Hooker's green and a touch of burnt umber, using a no. 8 round sable and enough water to get a middle tone. Later I apply a darker mixture (with less water) and use the point of the brush for details and to add the shadows to the darker sides of the trees. I am careful to paint around the roof of the shack so it will show up as a very light value against a dark one. I also drybrush the tree foliage around the foam burst carefully, so I don't destroy the soft edges.

Now I am ready to add a second coat of paint to the rocks. Using a darker mixture of ultramarine blue and burnt umber, I apply the darker lines and shadow with a ½″ (13 mm) flat sable brush. Near the foam burst, I allow the mixture to become somewhat browner by adding more umber to the mixture and let the rock color gradually fade into the foam by using more water. The walls of the shack are painted raw sienna.

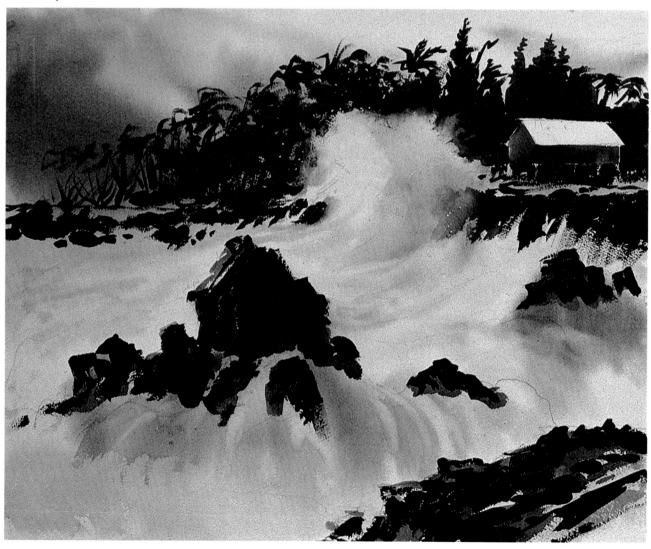

Keanae Point, 18"x22" (46 x 56 cm), 300-lb Arches rag paper, rough.

4. In this final step, I texture the tin roof and the sides of the shack with raw sienna darkened with mauve. The paper is totally dry and I use the point of a no. 1 sable to texture the roof. I add more green holes in the foam with Hooker's green, keeping them light and adding just enough of them to show the direction of the water's movement.

In the foreground, I now strengthen the shadows on the rocks with a mixture of manganese blue and mauve. The dark color gives more weight to the composition and also helps set off the foam burst and shack as the center of interest. Any more additions at this point and I believe the painting would be overworked, so I stop.

California Sunset

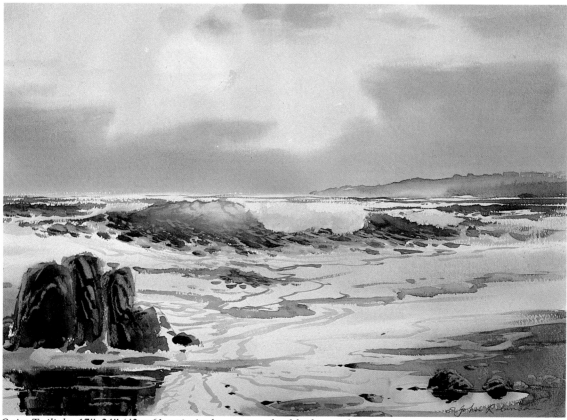

Quiet Twilight, 17″x24″ (43 x 61 cm), Arches watercolor block, rough.

The Big Sur is an area of coastline south of the Monterrey peninsula of California known for its high bluffs and rugged shoreline. At the Big Sur the road clings to the cliffs high above the water and there are few places to pull over, park, and search for a path down to the water's edge. But when you find such a spot, you will discover the trip—including the strenuous return—to be well worth the effort.

When the waves at the Big Sur are active, they rage against fortresslike bluffs and ancient rocks, and a beach or creek outlet is a rare find. In fact, low tide is often the only time when anything but rocks is available to stand on.

It was just such a setting that inspired this chapter and the development of the painting *Big Sur Gold.* Standing on a tiny beach there, and facing south, I looked into a fog-enshrouded winter sun, and watched its rays stabbing at the spray and mist of the oncoming waves. It was a special moment in a special place, a painting waiting for an artist or an appreciative eye. Moments like this belong only to those fortunate enough to see them, unless an artist is there to record it. Then, such moments are frozen in time and may be shared with others, a communication with nature through art.

The purpose of this chapter is to show you how to transfer some of the things you see and feel to paper: how to capture the atmosphere and the mood of a scene. But some of the special problems in this demonstration are tricky and may take some practice. The first, and perhaps the most difficult, problem is painting the glow of the sun. The sun's glow affects not only the sky, but also colors the bluffs and the waves. Since solutions to other problems, such as painting a translucent wave and a foam burst striking a rock, are found in previous chapters, we will concentrate here on painting the sun's glow. In painting *Quiet Twilight* (above) as often happens, I trimmed off an inch here from the original sheet of paper. I believe this is just as legitimate as pre-planning, only in this case it is corrective.

Quiet Twilight presents quite a contrast from *Storm Fury* and *The Big Sea.* Here the composition is mostly horizontal, which is a relaxing motif. The clouds, low headlands, wave, and beach are all made of horizontal lines, even though some may zig zag a bit. Only the rock stands upright and that is to relieve the otherwise striped effect created by too many horizontals. The light-dark contrast and the translucent water make the wave the center of interest. The warm, yellow sunlight shines right through the thin, upright wave and reflects nearly the same intensity.

1. After making a brief sketch of the scene on the paper, I wet the paper with a sponge and allow it to soak in only a few seconds. Then I mix a puddle of cadmium yellow light and water—using just enough paint to show up as yellow. Dipping a 1″ (25 mm) flat sable brush into the paint and making a circle of yellow around a 3″ (76 mm) circle of pure white paper, I run my circle outward for two or three inches (5 to 7.6 cm), painting right through what later will be the bluffs.

2. If I don't take too long to mix my paint, the paper should still be wet. If it is not—and I can tell with my first stroke—I re-wet it. I want this stroke and those that follow to flow into the previous ones without leaving any edges. Now, using the same brush but adding a bit more cadmium yellow light and a touch of alizarin to the puddle, I form the next circle of color near the outer edge of my first circle. I continue to make concentric rings, moving outward for another two or three inches. The new, darker, and warmer mixture should gradually blend into the pure yellow of the first circle.

3. This step almost always requires re-wetting the paper, unless I am working very fast and the paper is still wet. But the paper must be either wet or completely dry. If it is merely damp, the sponge will smear the paint. I re-wet only the area I need, in this case just inside the outer edge of the last circle, moving outward into the unpainted area. This will allow my next strokes to blend with the preceding ones.

I now add a bit of ultramarine blue to the existing puddle of cadmium yellow light and alizarin. The color may appear a bit muddy at this point if there is too much yellow and blue in it, so I try to tilt the color toward the purple side by adding more blue and alizarin. Then I paint outward from the last circles and cover the rest of the sky area, still using the 1″ (25 mm) flat brush.

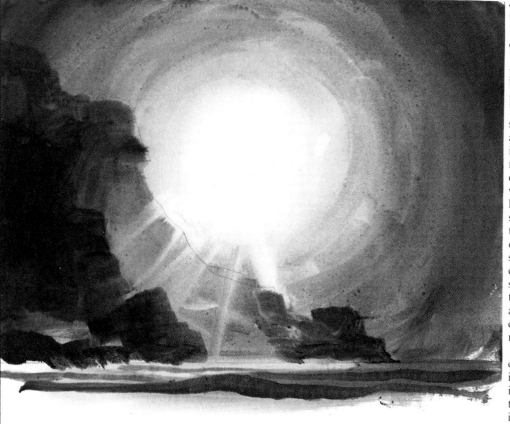

4. In this final step, I paint in the bluffs and foreground. First I re-wet the paper—in the area of the bluffs only. Then, with a ½″ (13 mm) flat sable brush, I paint the bluffs with burnt umber and a touch of the left-over puddle of sky color. Notice that I lighten the color nearest the sun with water and darken the area away from the sun by using less water. I paint the nearer bluffs even darker to contrast with the glow. Finally, with the bluff color still damp, I lift off paint with the sponge to show the sun's rays. I start in the white area of the sun and drag the sponge downward in a straight line. Then, with a cleaned sponge I repeat the strokes three or four more times. Notice that the rays radiate out from a hub and fade the color of whatever is underneath.

Practice painting sun glow on scrap paper until you can do it successfully before attempting it on a painting. It takes time to develop such skills, but it can be done!

Linear Sketch. I have not gone into detail here as that is not my goal. I merely want a simple guide to follow when I paint. By sketching an outline ahead of time, I can see where I may wish to make changes. In other words, this is really a compositional sketch rather than a drawing that is meant to be a final product.

In this case, I have placed the horizon line above the center, slanted the background lines downward, and made the foreground lines flatter and curved. This helps to show the movement of the water as opposed to the harder lines of the rocks and bluffs.

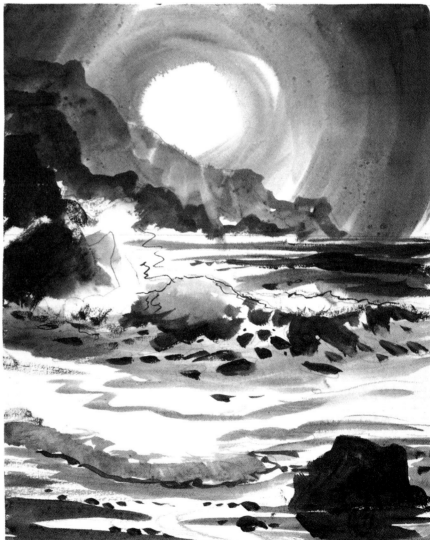

Value Sketch. A value sketch divides the composition into areas of light, dark, and medium areas. I no more intend this as a final product than I did the line sketch. This, too, is a compositional guide.

In this sketch, I have balanced the darker headlands with the foreground rock and have surrounded the major wave with light. The sky appears a bit too dark for me, so I make a mental note to lighten it when I paint the picture. This is what sketches are for—to show where corrections are necessary before it is too late! This sketch will now enable me to proceed with the actual painting.

1. I first draw a basic outline on the paper to use as a guide. I use as few strokes as possible for this; the fewer lines now, the fewer I will have to erase later. Even though I am concentrating on the sky area, I wet the entire paper with a sponge as a preliminary step before painting the sun's glow.

I paint the glow as I did in the demonstration earlier in the chapter, using a 1″ flat sable brush. I begin at the center with cadmium yellow light and work outward with a touch of alizarin crimson, then with a bit of ultramarine blue since the color gradually grows purpler as the glow moves outward into the blue sky. Then, because the sky reflects its color on the sea, I add a few brushstrokes of sky color to the foreground. (I re-wet the lower area of paper first so the colors are soft-edged.)

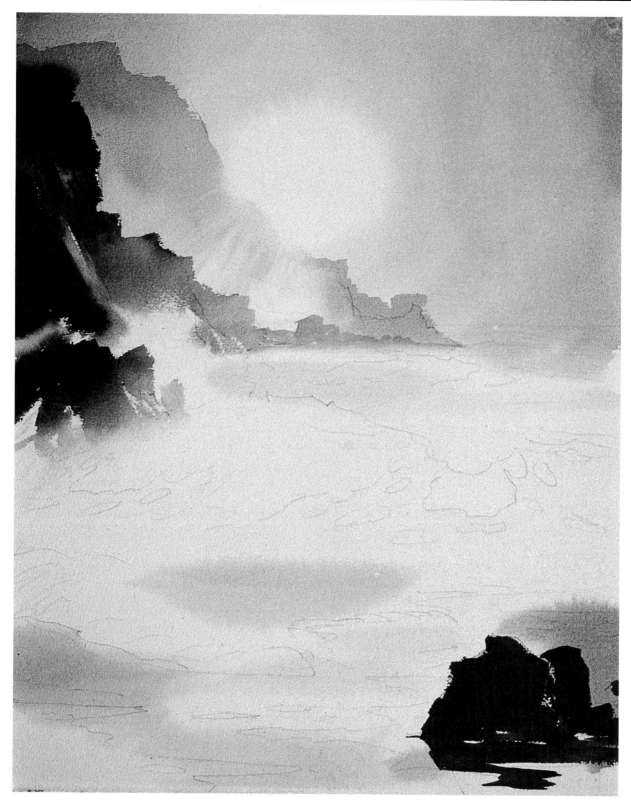

2. Now I paint the headlands. The paper has dried in the sky area, but I re-wet only the area I plan to paint. Then I mix raw sienna into water and add a touch of ultramarine blue and alizarin crimson to it. Starting at the top of the bluff using a 1″ (25 mm) flat sable brush, I paint downward, adding water to lighten the color as I reach the glow area. Then while the paint is still damp, I sponge out the sun's rays. The next two headlands are the same colors, but with less water. Again, I start with darker paint at the top and lighten the color as I approach the glow area.

The lower rock and foam burst are handled differently. I re-wet the paper and paint the rock with the 1″ flat sable brush, fading the color into the foam burst. The beach rock is painted with the same brush, but now the paint is mostly raw sienna and alizarin with a touch of blue. I don't bother to re-wet the area, however, because I want harder edges there.

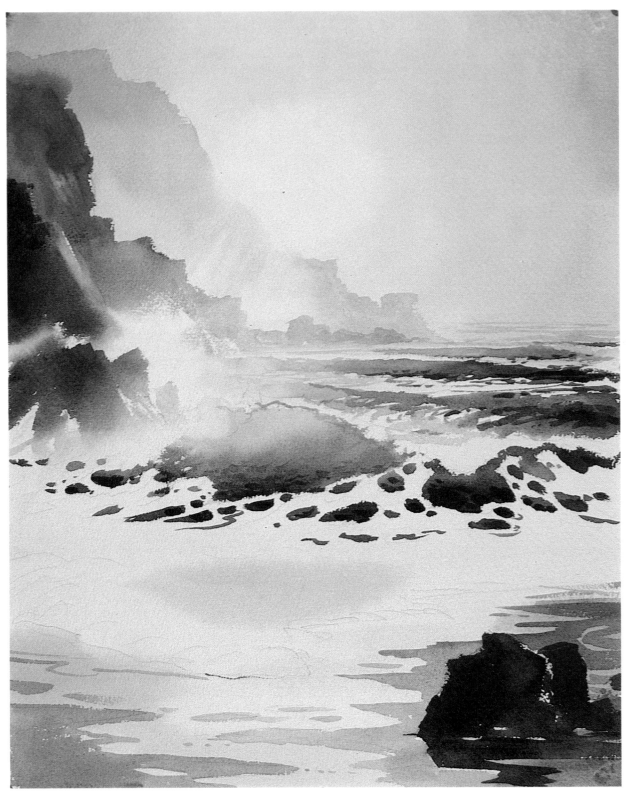

3. Like the headlands, the background swells must also fade into the sun's glow. But this time, instead of working toward the glow, I start with the glow itself and work outward. First, with a no. 8 round sable brush, I mix a puddle of cadmium yellow light and apply it to the glow area on *dry* paper. As I move toward the right, I add viridian to the color, then a touch

of burnt sienna at the far right. I do this to each wave. Notice how the waves change from light to dark and from yellow to dark green as they get farther from the sun.

I use the same brush and colors for the major wave, too. I start the wave with the darkest color, spotting in the holes in the foam and the lower portion of the trans-

lucent area. Then I add water and more light yellow as I work upward to the top edge.

Finally, I paint the sand with a no. 8 round sable brush, using raw sienna and a touch of ultramarine blue. Again, I lighten the color with water as the sand approaches the sun's path.

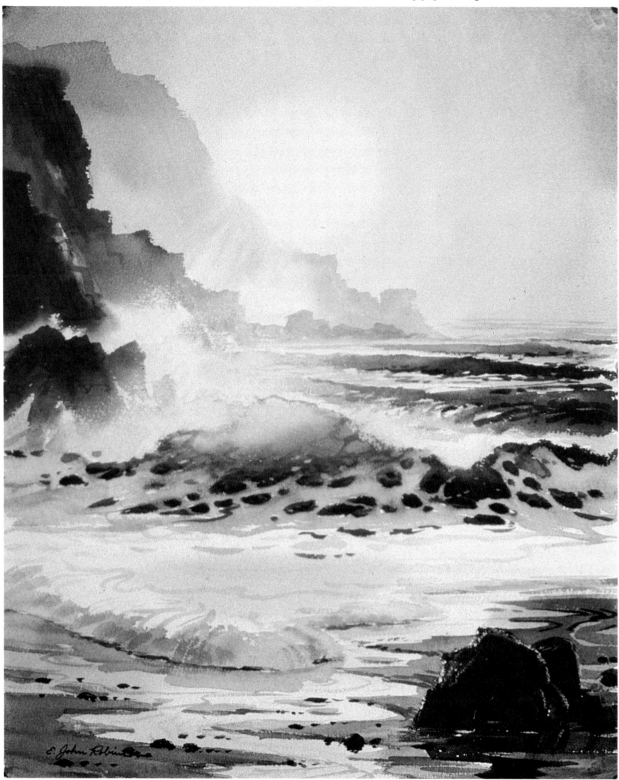

4. For the final touches, I shadow the foam patterns on the wave. I use cerulean blue for the darker patterns because cerulean is somewhat opaque and covers the underpainting. For the lighter patterns, I use ultramarine blue with a touch of mauve to warm it. I work with a no. 8 round brush and continue using the same color to shadow the edge of the foreground foam to give it depth. I also make a few lines on the water's surface to show movement in the foam.

Next I texture the rock with burnt umber and paint in the pebbles at the same time with a 4" (10 cm) round sable. I scratch out some highlights on the rock with the point of my knife. Then, with coarse sandpaper, I scrape out more mist in the foam burst in the area of the glow. After adding a few final shadows of raw sienna and ultramarine blue to the sand cusps, the painting is complete.

My goal in this painting was to capture the feeling of misty sunlight and the wild ruggedness of the Big Sur coastline. I feel I have done this—and I believe you can do it also.

Oregon Beach

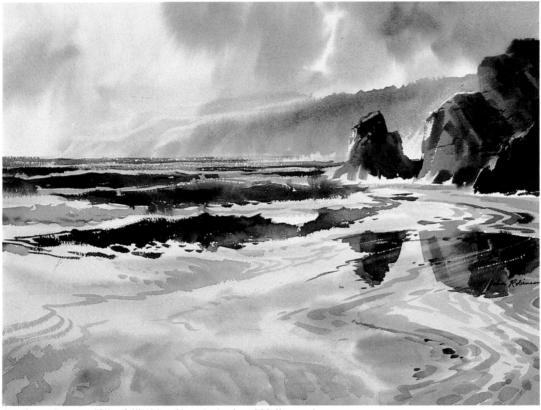

Southern Oregon, 18″ x 24″ (46 x 61 cm), Arches 300-lb rough paper.

I have a special love for the beaches of northern Oregon because, as you know by now, I grew up along that coast and struggled with my first paintings there. Yet even within such a limited area, the sand—as well as the rocks, vegetation, and water—would change color, sometimes within even a few hundred yards. The point is that every beach has its own distinct personality and the artist is fortunate in having the pleasure of noticing these differences and recording them.

If I were to paint a beach as a secondary part of a composition—that is, showing very little beach—I would do little more than paint the color and add a few textures to insure that it looks like a beach. But if I chose to feature the beach as the main subject with the sea as a background, then I would try to include one of the many interesting features that can be found on a beach. For example, a point of interest for me might be a tide pool, with a reflection of a rock

or headland. Or it might be a piece of unusual driftwood or some clumps of dune grass with the colorful verbena that always offers a bright spot. Sometimes I may use a creek outlet or a grouping of rocks or a combination of any of these features. The trick is selecting and focusing on one main item and perhaps one or two secondary interests. Too many points of interest only confuse the viewer and clutter the composition.

The color of sand can be difficult to capture. Not only does it vary from place to place, but it also reflects the sky when it is wet enough—and the sky changes color with the time and mood of the day. I have found Naples yellow to be a good sand color, as long as it is merely the base or a starting point for a color mixture. From there, Naples yellow can be warmed or cooled, or lightened or darkened, according to the requirements of the particular scene. I usually warm Naples yellow with raw or burnt sienna and cool it with

whatever blue I use in the sky. Either of these additions may darken the color, but its value can be controlled by the amount of water that is added before applying it to the paper.

Occasionally I come across an area such as the one in the painting above with all the elements of a seascape: sandy beaches, rocks, headlands, and an active sea. When they are all included, you must concentrate on only one element or your composition will become too busy.

For the base underpainting, I worked on wet paper with soft, gray-purples and greens mixed from ultramarine blue, a touch of alizarin crimson, and watered-down viridian. On top of this, I added darker viridian for the waves and burnt umber with ultramarine blue for the rocks. The darker values plus the harder edges—the paper was drying—focuses the attention exactly where I want it and I have avoided making a busy composition out of a painting with so many elements.

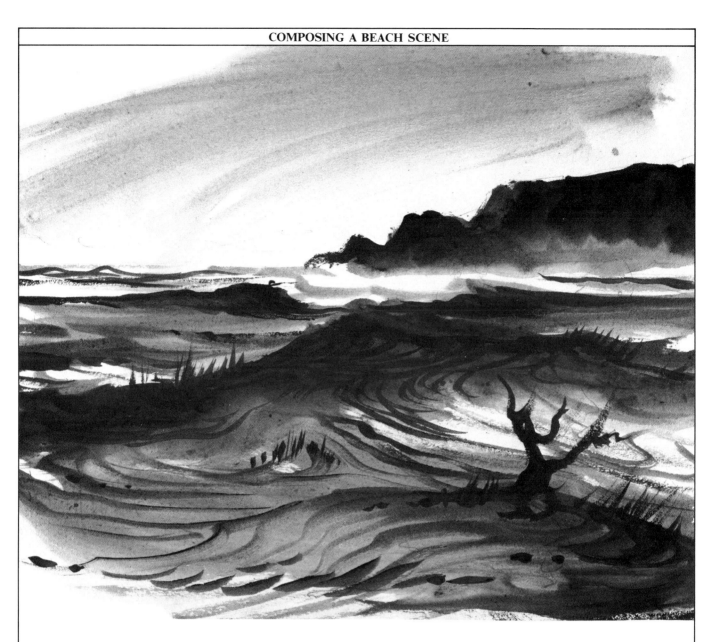

Sand Texture: Wind Ripples. When you wish to play up the beach itself, you can emphasize the textures of the sand by painting wind ripples or sand bumps on its surface. Wind ripples are linear ridges formed in the sand by the action of the wind. You can use them to describe the contour of the sand dunes or mounds. In fact, in many cases, they actually form the contour of the sand. In this illustration, notice that most of the lines of the wind ripples are subtle—that is, they are only slightly darker than the sand on which they lie. If these lines, which are really shadows, had been made darker, they would have been much too prominent.

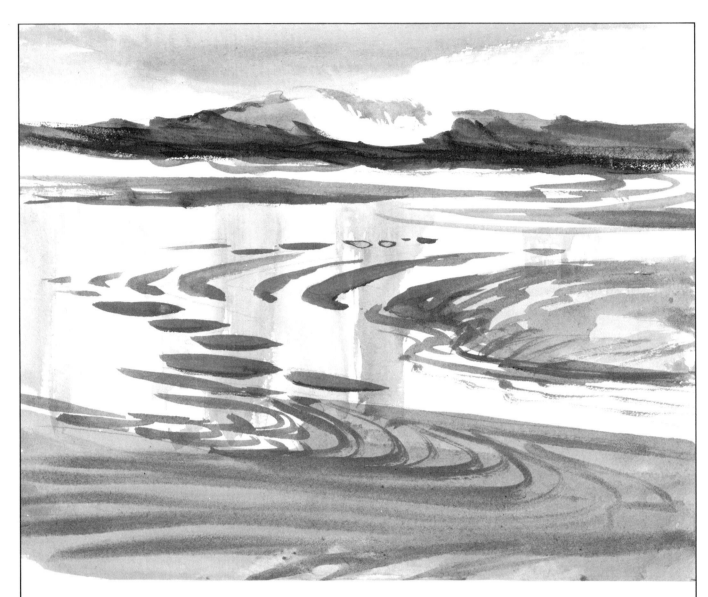

Texture: Sand Bumps . After the
tide washes over the sand and recedes,
the sand is left in ridges and bumps not
unlike those left by the wind. These
slightly raised patches of sand stand out
against the vaster flatness of the beach.
The wet sand reflects the sky and nearby
surroundings, but the raised bumps are
drier and therefore contrast with it in
color or value. Sand bumps and ridges
are ideal for creating texture or lead-ins
to a focal point in the composition. Com-
bined with an outlet, they may also show
the swirls of moving water and the con-
tours of the beach.

Reflections. There is a lot of potential interest in a rock, tide pool, and reflections if you are willing to take the time to add the detail a center of interest requires. To paint this particular rock and its reflections, I began with the sand, painting it with a 1″ (25mm) flat sable brush and watered-down paint on dry paper. Because the paper was dry, the brush left sharp edges around the rock and tide pool. When the wash dried, I wet the tide pool area, stopping just short of the sand, and painted first the rock's reflection, then the rock. Since the paper was nearly dry, the rock has hard edges, but the reflection, painted on wetter paper, "fuzzed out." This gave the water the appearance of a slight movement and added softness to the image. Of course, I was careful to reflect the rock textures in the water below.

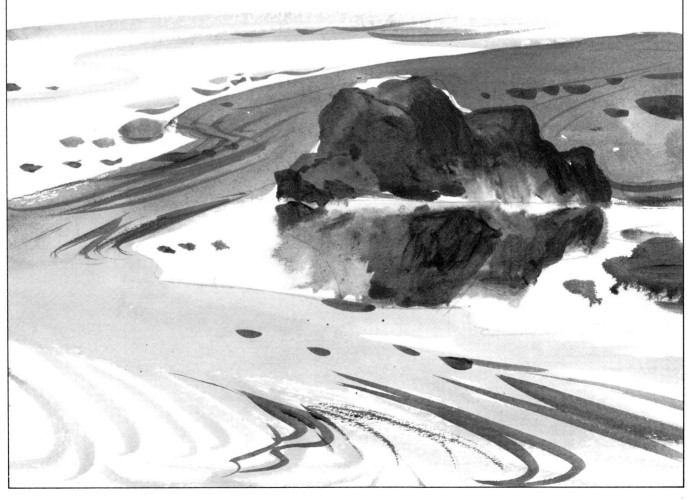

Outlet with Ripples. Like sand or reflections, outlets make a good center of interest or lead-in to a center or interest in a beach scene. When painting an outlet, you may wish to show the ripples that form on its surface as the water flows into the sea.

There are several things you should understand about ripples and outlets before you paint them. They are illustrated here. First, note that the surface of the water is flat. It is darker in the foreground, where its transparency reveals the darker sand below, and gradually lightens as it recedes into the distance, where it mirrors light of the sky. On the contrary, the ripples in the water are slanted in other directions and, depending on their angle, reflect the colors of the sky, sun, or surrounding beach. Thus the ripples contrast in color and value with the flat surface of the water.

To paint this scene, I used a 1″ (25mm) flat sable brush and wet paper. I painted the water first, grading it from dark to light as it moved into the distance. I also graded its color—from a burnt umber gradually into a light ultramarine blue where it reflected the sky. When the paper dried, I painted dark ripples over the light distant water with a no. 6 round sable brush and ultramarine blue. Then, for the foreground water, I used only clear water instead of paint and swirled the brush over the dark area. After waiting a few minutes until the water soaked into the dry paint, I dabbed the lines with a clean tissue and lifted off the color. The result was light ripples on dark water.

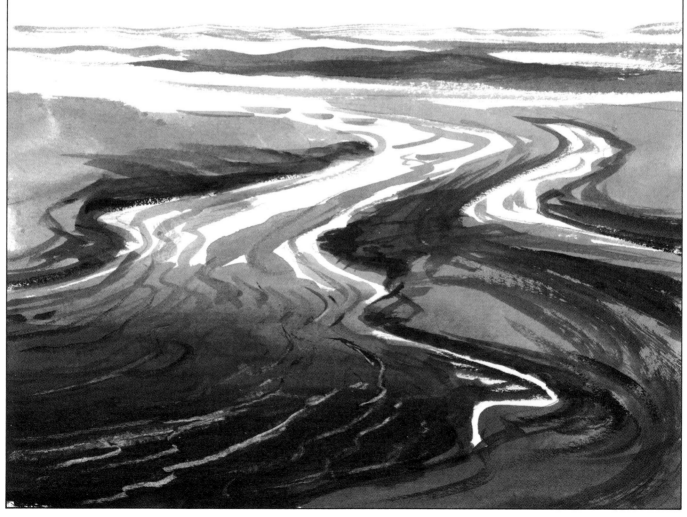

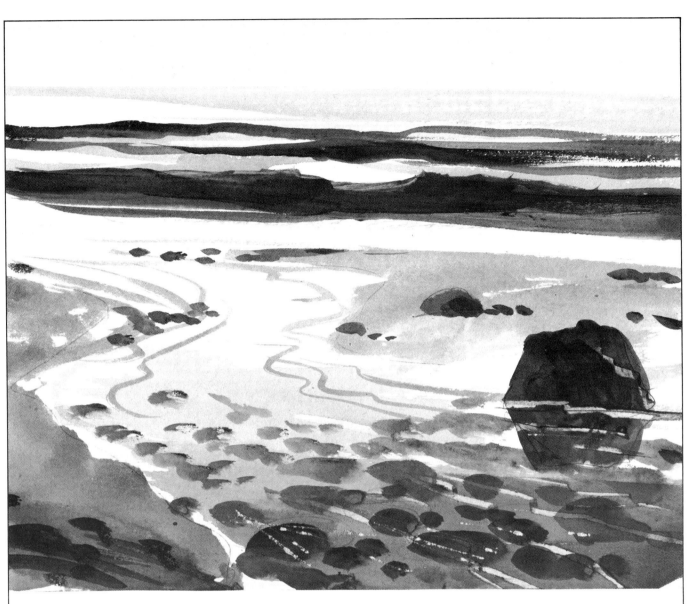

Outlets with Rocks . The water in an outlet may be clear and show rocks and sand beneath its surface. To paint this type of outlet, I wet the paper and painted the sand using a no. 10 round sable brush and Naples yellow. I made the foreground very light, then faded it out altogether as it reached the surf. When the paper was dry, I painted the rocks with the same brush and watered-down burnt umber. Like the sand, I also lightened them as they receded from view. After the rock colors dried, I washed the sky color (cerulean blue) over the outlet area. Again, I started with darker color in the foreground and gradually lightened the color by adding more water to the paint as the outlet receded. The final effect was achieved by scratching in a few ripples with a knife.

Driftwood. Driftwood can also be a focal point in a painting, especially if it is as interesting as this piece, although I prefer to use it as background or filler to break the monotony of large areas of sand. But an occasional especially interesting piece of driftwood, such as this one, just has to be featured.

I begin this example by painting the sand and background. In this case I painted the sky with a wet brush on dry paper, which allowed me to paint around the driftwood, leaving crisp edges. (If I had wanted a wet sky, I could have covered the driftwood with tape or masking liquid instead of painting around it.) I allowed the first step to dry completely, then carefully re-wet the tree. With a no. 4 round and burnt umber, I painted the shadow side, allowing the edges to run a bit. Next, as the paper dried, I painted the cracks and the shadowed twigs, first making sure my no. 4 brush had a fine point. I still continued to use the umber, but darkened it in some areas with a touch of ultramarine blue.

Logs. Beach logs are seldom main features in a painting, but they are important accessories for adding weight to a composition, pointing to a center of interest, or simply breaking up an uninteresting space. The logs here were painted in the same manner as the driftwood. I first painted the sand around the outline of the logs, then, after it had dried, rewet the logs and painted their shadow side. I textured the logs as the paper dried, so the earlier lines fuzzed out at first and as the paper dried, later lines were crisper. I like this technique and believe it helpful in adding a variety of texture to a painting.

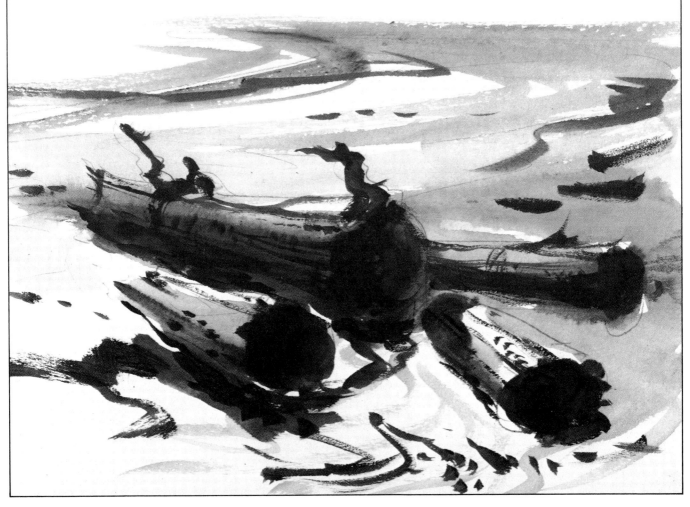

Linear Composition. For the color demonstration that follows, I have chosen to paint a creek outlet on an Oregon beach. But because of my angle of view, I decide that a vertical format would best show both the creek and the sea. It also allows for a longer, lazy, meandering line leading to the sea, which enhances the feeling of restfulness. I intend to center the focal point around the rock where a striking wave will create a foam burst. Notice that the lines of the clouds also extend toward the center of interest.

Value Composition. This value sketch shows that even a distant center of attention can be strong. The lightness of the foam burst contrasts with the darkness of the rock. Backed by the nearly-as-dark headland, this area maintains the highest contrast in the composition.

Once the center of interest hangs together with contrasting values, I find it wise to play down the values in the remaining spaces. Although other areas must also have lights and darks, they need to be much more subtle or they would distract from the focal point and create too much activity in an otherwise calm composition.

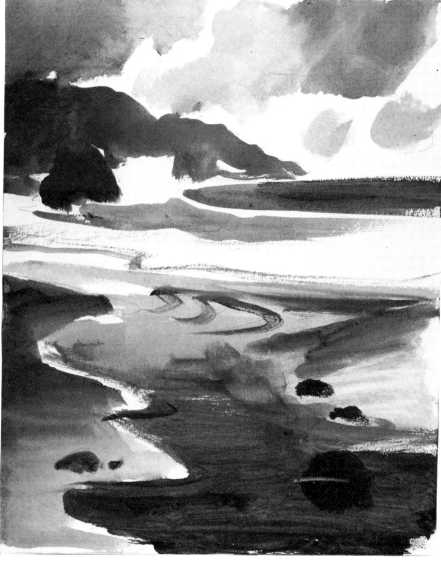

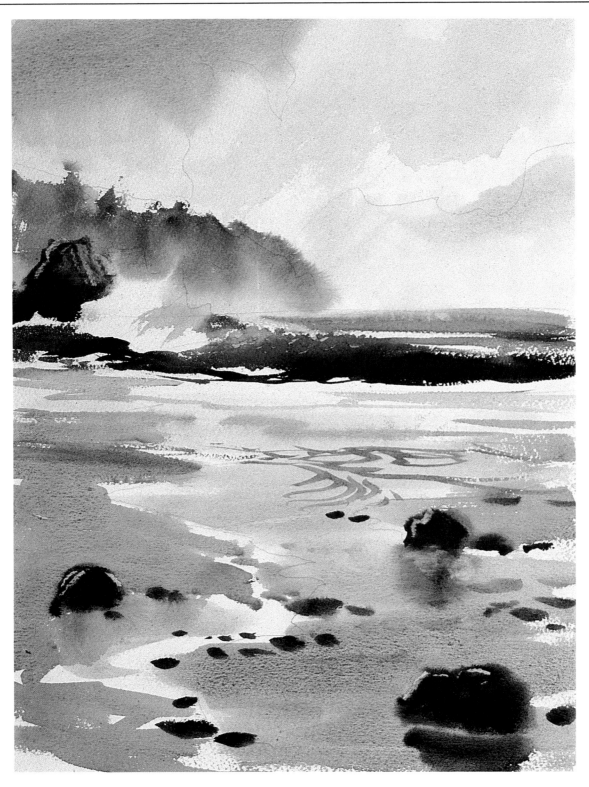

While it is not always necessary to make a color sketch, I often do so anyway. For one thing, it helps me get the feel of the colors I wish to use and the mood of the day. For another, it gives me the opportunity to make mistakes that can be corrected on the final attempt. Remember, it is important to take your time at the beginning of a painting. Rushing into the final painting with excitement may lead to disappointment. I find I am just as excited about the painting after going through the usual preliminaries as I was initially, but now I can proceed with much more confidence.

I do most of my color sketches on a 9″x12″ (12 x 30 cm) rough-textured watercolor block, which I usually keep with my field kit. (The smaller size block allows for ease of carrying.) I painted this entire sketch in less than ten minutes using viridian, burnt sienna, cerulean blue, and Naples yellow. Later, in the actual painting, I added other hues for more subtle nuances of color. However, in doing the sketch, I am not concerned with making a finished painting but in capturing the essence of the mood and scene.

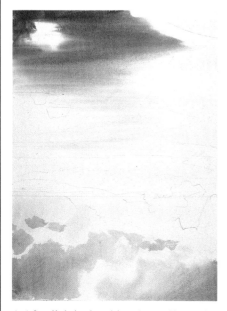

1. After lightly sketching the outlines of sky, water, and land, I wet the paper with a sponge. Then, using a 1″ (25 mm) flat sable brush, I paint the blue area of the sky. I use cerulean blue at full strength in the upper left-hand corner and fade it as it nears the clouds. I leave the clouds unpainted but add some light blue beneath them near the horizon line.

I work on the outlet next because it should reflect the sky. With a 1″ (25 mm) flat brush, I apply cerulean blue, but mix burnt sienna with it to show the sandy bottom. However, as I brush toward the distant surf I stop using the sienna and fade the blue completely by the time it reaches the shore.

By now the paper is barely damp. I re-wet only the upper edge of the clouds and mix a watered-down blend of cerulean blue and burnt sienna. With a no. 10 round sable brush I start at the upper right with the darkest mixture and fade it into the re-wet area. I stay back from the edge of the cloud so the shadowed area fuzzes out but leave the upper edge of the paper white. The lower portion of the cloud has a somewhat crisper edge because the paper there is nearly dry. This creates a nice contrast in edges.

2. I want the upper portion of the headland to be crisp-edged but wish the foam burst to be soft-edged. Therefore I re-wet only the bottom portion of the headland and with a no. 10 round brush I scrub in Hooker's green deep with a touch of burnt sienna. I carefully paint the headland around the area of foam and rock. Then, with a no. 4 round brush, I paint the crisp lines of the trees on top of the sky area and make additional strokes over the now-drying headland.

For the sand color, I choose Naples yellow. I do not re-wet the paper, but with a 1″ (25 mm) flat brush and plenty of water, I wash in the area. I keep away from the edge of the water on the left because I want the effect of light glistening on the sand. While the wash is still wet, I brush cerulean blue over some of the sand to reflect the sky. I also make a few strokes of sand color in the water and direct a few sand bumps toward the surf.

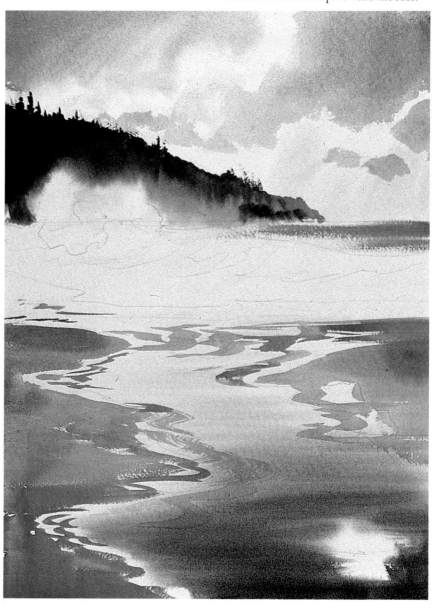

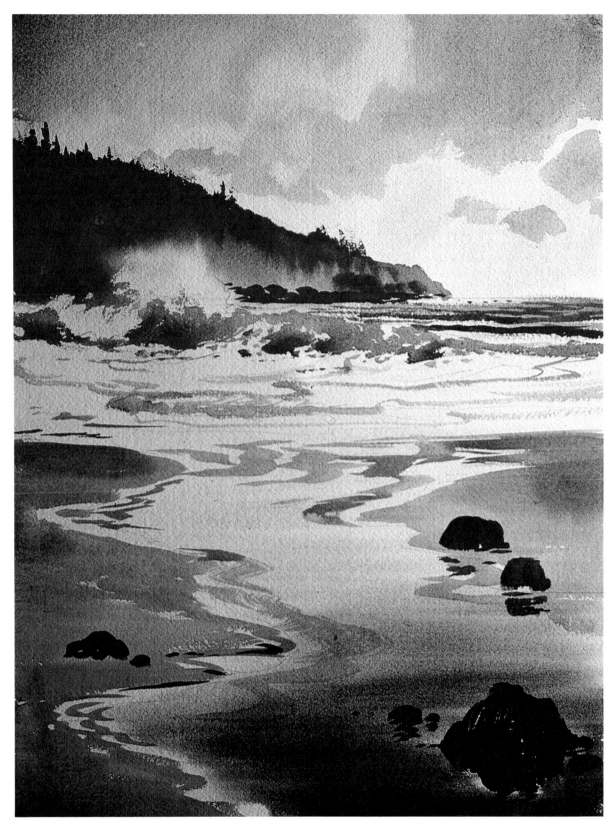

3. I begin by underpainting the rocks with burnt sienna darkened with a touch of Hooker's green. I re-wet the edge of the big rock near the foam and fade the color up to it. I also add a few rocks to the background.

For the background sea, I use a no. 6 round and paint the swells with cerulean blue. Near the wave, I add some Hooker's green to the cerulean. The wave itself is Hooker's green only. I start the wave at its lower edge on dry paper and lighten the color with water as I move up. I paint around what I want to be foam patterns with a no. 10 round brush. As the green paint dries, it becomes too light at the bottom, so I add a stroke of cerulean blue to darken it as well as to reflect the sky.

Oregon Beach, 24″x18″ (61 x 46 cm), 300-lb Arches rag paper, rough.

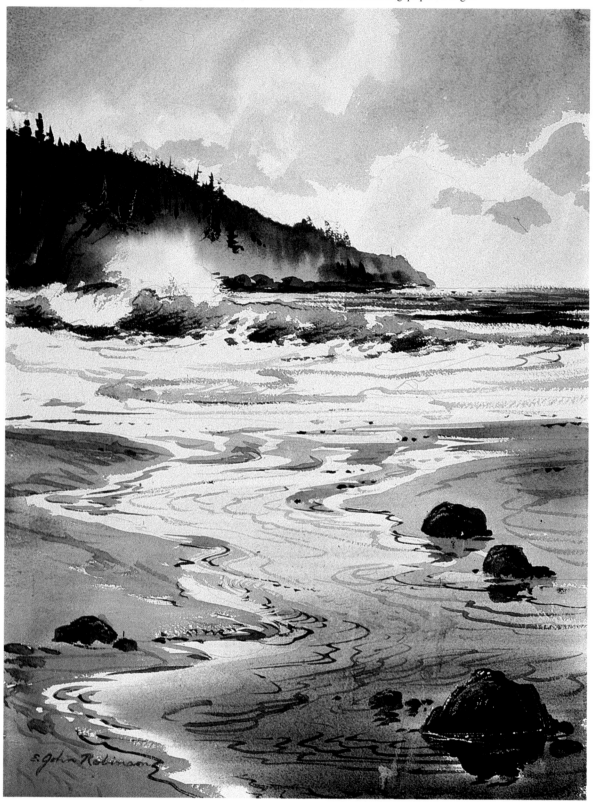

4. The entire final step involves texturing and working a no. 2 round over dry paper. For the foreground foam, I paint a few shadow lines of cerulean blue. I also add the wind ripples over the sand with Naples yellow darkened slightly with cerulean blue. Where the ripples appear above the water, I use cerulean blue, which is darker than the underlying blue where I have used more water. I start the ripples with dark blue in the foreground but, like the water, I gradually lighten them as they recede into the distance.

The pebbles and the texturing of the foreground rocks is done using burnt sienna, with Hooker's green to darken it. Because the paper is dry, this overlay of color did not lighten as the underpainting beneath it had when the paper was wet.

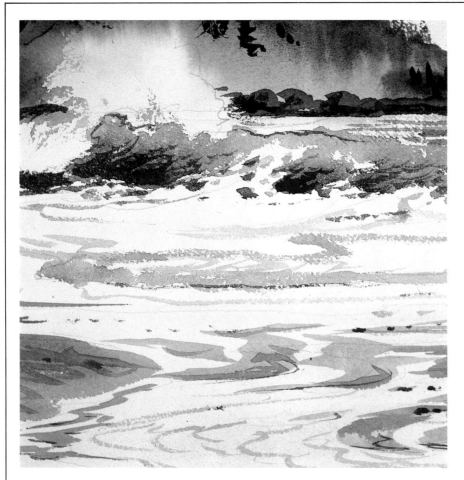

Detail of the Wave. Notice the contrasts in edges in this detail. The edges of the foam are soft because I worked on wet paper. The edges of the sand are slightly crisp because I worked a wet brush over nearly dry paper. And the edges of the rocks and lower side of the green water are hard because I brushed a fairly dry brush over dry paper. These contrasts in lines and edges add interest and quality to a work of art.

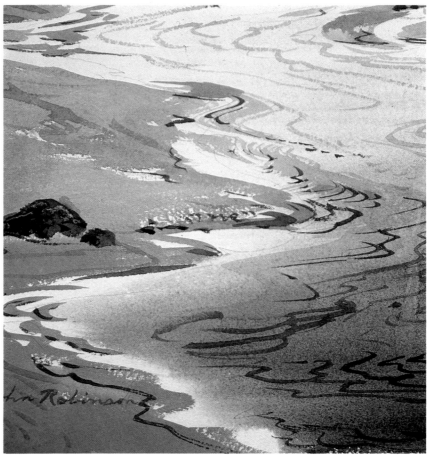

Detail of the Texture. I show this detail to explain further how I textured the painting. Looking back on Step 3 of the demonstration, you will see that the overall effect I had set out to accomplish was already there. That is, the painting looked like a seascape with a creek outlet. In Step 4 I added texture to break up larger areas and to add subtle interest around the composition.

The trick in texturing a painting is knowing when to stop. You must add only enough lines and spots to convince the viewer that the area is textured, and you must keep these additions subtle. That is, there can't be too much contrast between the underpainting and the textured overlay.

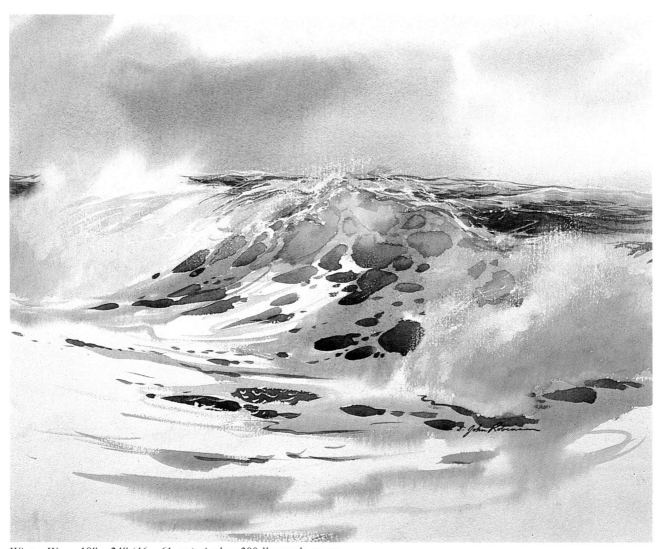

Winter Wave, 18″ x 24″ (46 x 61 cm), Arches 300-lb rough paper.

This is a simplified composition, a brief statement of a wave made important by patterns and textures. The sky serves to offer contrast both in value and texture. It is darker than the wave foam and softer than the crisper edges on the wave face.

The background sea is kept low because it is less important than the wave, yet necessary to add contrast behind it. The foreground contains little more than three or four brush strokes to lead the eye to the wave. The colors are soft gray-blues and greens except for the stronger ultramarine blue and Hooker's green light I used in the wave.

Part Three

TIPS AND COMMENTS

Finding a Subject

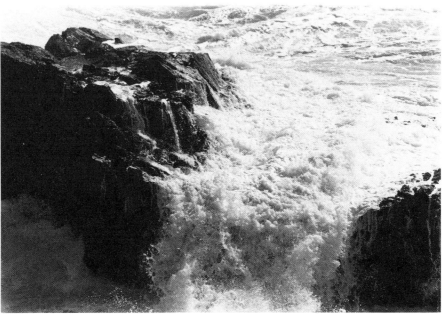

Gather raw material.

I have spent more than one day in complete frustration because I let someone else drive and decide where to paint. This was unfortunate for me because I kept seeing all kinds of possibilities as we drove. My companion, however, was more critical. There was always something wrong with each spot: Either the subject was too cluttered or it was too sparse. Some spots were appraised as too difficult to paint and others as too simple. On the other hand, in my philosophy, there are no ready-made subjects. And I have never, especially since I have begun painting the sea, found a perfect scene. For one thing, the sea is always changing. And for another, I was taught that artists are supposed to be creative!

When I search for a scene to paint, I look for one or two elements that I feel are outstanding—something that really "grabs" me. This is all I need. Then I work out the rest with my approach to composition. That is, I build my composition around the one thing that caught my eye. The result is that I build my painting around a center of interest, a special moment that others are not there to see.

Especially in painting a moving subject, such as the sea, those special moments sometimes exist for only a fraction of a second or they are merely a tiny portion of a larger scene. A painting may be triggered by the way sunlight strikes the curl of a breaker or by a different wrinkle in the surf foam. Or it could be inspired by the way water pours from a rock or by an unusually different wave or foam burst.

Sometimes that special moment is only the way a shadow is cast or the way sunlight dances over the leading edge of a wave (page 131). Sometimes it is a different set of foam patterns or a color change of extra beauty. But whatever creates the moment, it is special and you have seen it. Perhaps it is the destiny of the realistic artist to record such moments for those who weren't there.

When that special moment arrives, you will also know it when you see it. It will be something that will "grab" you. You then will have the kernel of a painting idea, the seed that will grow to a full composition, thanks to your creativity. At that point, sit down, draw the scene, and make notes about your special spot or moment. Then work out what is to surround it.

Remember, artists are not supposed to be cameras, faithfully copying what is in front of them. Go ahead, move a rock, change a wave, add or delete objects, change the direction of sunlight, or cast a shadow. And take advantage of cloud shadows. They are artist's friends. Place them wherever you need to darken a value. On the other hand, add sunlight wherever you need to lighten the values. But work it all out *before* you start painting. Remember, you are preserving something special.

Building a Composition
There are no ready-made compositions. When you find something special, record it with either camera, sketches, or memory. Your creativity can then be put to work finding a suitable set of surroundings for your special moment.

In the photograph on this page, I have recorded a fantastic rock. The combination of trickles and flowing water is also special. But there is no major wave and as a composition, the contrast between light and dark is too strong. I will have to set to work with thumbnail sketches and incorporate more surf and more values.

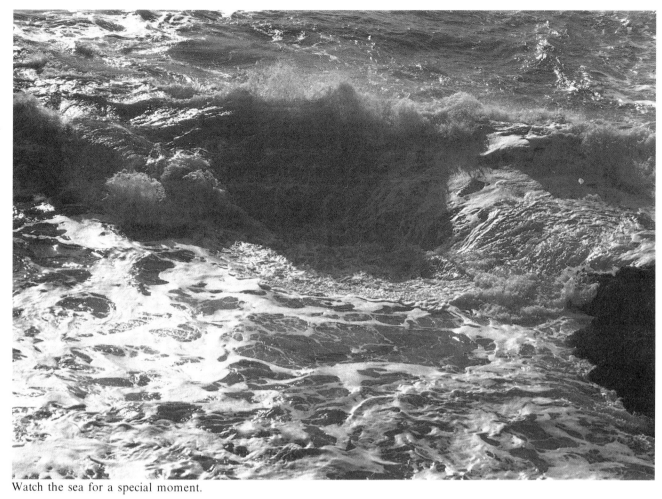

Watch the sea for a special moment.

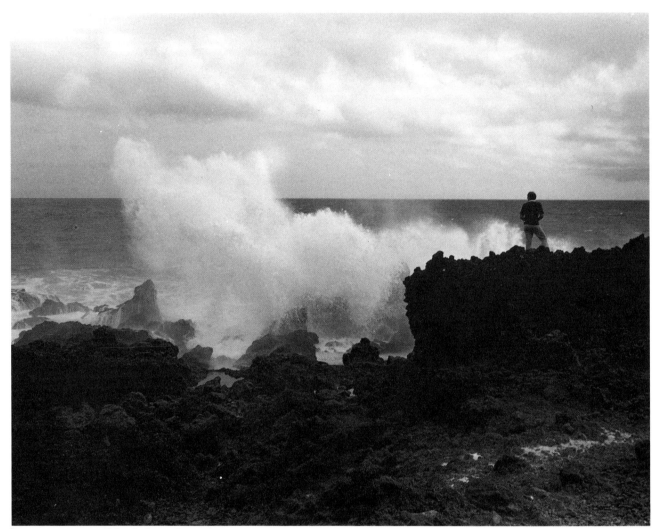

Be sure to stay well back from the action.

Stopping the Action

When I first began to study the sea, I was overwhelmed by the amount of action within my vision. It was simply too much to see and comprehend all at once. Also, the scene continually changed and nothing stood still long enough to be properly sketched.

At first I tried taking snapshots with a cheap camera, but the resulting photographs were of poor quality. The scenes were too far away and I knew enough not to get any closer to the sea, physically. Besides, I always missed the right moment.

Watch the sea, by all means, but don't forget to stay well back from the action! I was on the Keanae peninsula in Mau, when the photograph on page 132 was taken. I was safe because a series of rocks broke up the crashing waves before they reached my perch. Remember, the sea has no rules. It may be calm one minute and violent the next.

Movie Camera

I then tried a movie camera, with better results. It was an 8mm movie camera with a zoom lens and a slow-motion device. I could focus on a wave just beginning to build and follow it through until it broke, recording every moment. My projector could slow it down even further and I could stop it at any frame to study an important point. I learned most of what I know from that approach.

Unfortunately, the cost of operating a movie camera is high—and shooting film in slow motion is even more expensive. This is because, to achieve slow motion, the film must race through the camera at a higher speed than normal. So, standing at the shore shooting reels of color film is akin to standing at the shore throwing twenty-dollar bills to the sea gulls.

Eventually, with more experience and a better understanding of the sea, I was able to observe it more carefully. I learned to watch the sea through the lens of the camera and anticipate when something special was about to happen. I also learned to look for specific moments. For instance, I learned to watch for the tip of a swell, knowing it was about to break. Or I would focus on a spot where I knew a wave would break, or where I expected foam to split into holes, or where I knew a wave would strike a rock and send up a foam burst. Finally, I learned to ignore 95 percent of the action I saw and seek out only the unique.

Still Camera

Eventually I went back to a still camera. I bought a good 35mm single lens reflex camera and a powerful telephoto zoom lens that ranged up to 240mm. Now I can stand well back from the action and focus on anything within the area of the breakers. Also, because I learned to anticipate special moments, I can focus ahead on a spot and be ready when the right moment arrives. Then, when it happens, I merely push the cable release and I have the picture I want. For shots like this, I set the shutter speed at 500. High shutter speeds stop the action without blurring the picture.

A telephoto lens permits you to focus on action too far away for an ordinary lens. Notice the clarity of light and shadow that the camera

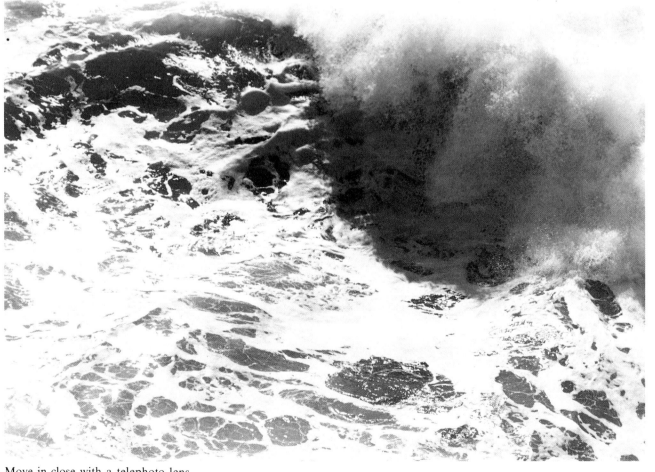

Move in close with a telephoto lens.

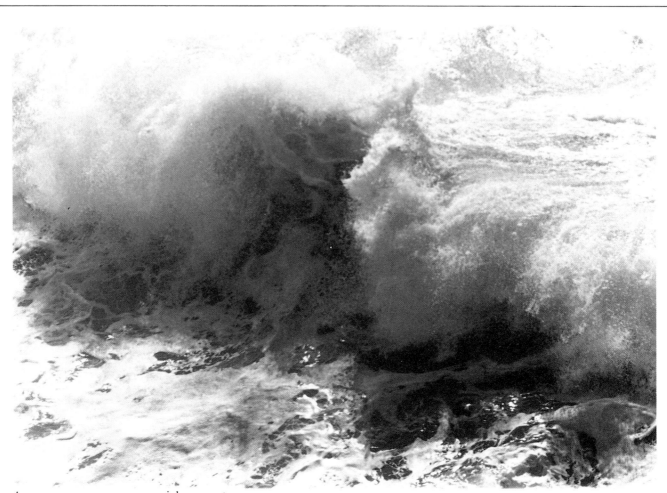

A camera can preserve a special moment.

caught at the moment the photograph on page 133 was taken. I froze the action by setting the camera shutter speed at 1/500 second.

When you are observing the sea, look for a special happening, something unusual, and have your camera ready. I watch the sea through the camera lens and am therefore ready to press the cable release in an instant. The photograph on page 134 is a good example of a special moment that would otherwise have been lost without my camera.

A word of caution regarding photographs. Use them for reference only. Remember, you are looking for special moments and special action, so no photograph will have a perfect composition. But your creativity will help you to base a composition, on even the smallest of ideas. So use photographs for inspiration only. Copying them exactly as they are may make your paintings look as if they have been copied, something even a layman can detect.

Viewfinder
Even if you don't own a movie or a still camera, you still have eyes! Here is a technique I have learned to use with good results: I hold my hands on either side of my eyes, then curl my thumbs and forefingers in a squarish shape to make a frame. The rest of the hand works rather like the blinders on the harness of a work horse in shutting out extraneous scenery.

Instead of using your hands, you can make a viewfinder out of a piece of matboard or heavy cardboard. Cut out a hole in the board no larger than 5″ x 7″ (12.7 x 17.9 cm), leaving a border around the hole wide enough to block out the surroundings.

To use a viewfinder, watch the sea through your hands or the paper viewfinder until you see something special. Then turn away immediately and make a quick sketch and written notations of what you've just seen. Use your memory. Play the moment over and over and don't turn back to the sea until you have recorded the moment.

Visualization
Your memory may be your best study guide after all. You have probably stored far more information there than you think. The more you observe the sea, the more you will store in your memory bank. All you need to do to recall a moment is to play it back in your mind's eye like a movie projector.

I have found that if I sit or lie comfortably in a room with a minimum of distractions, I can replay endless vistas I have seen. The mind has a way of putting information together and replaying complete scenes—moving and in color. I am amazed at the amount of detail as well. For example, I can visualize an oncoming swell, zoom out to meet it for a closer look, and watch it through its final stages. I can also stop the action at any point, move in and around a wave, examine details, then set it in motion again. The mind will play any game you wish, but it can only give back what you have put into it.

To develop the ability to visualize, it is imperative to spend as much time as possible observing the sea. You must also discipline yourself to recall those scenes in your memory bank. It may take quite a bit of practice, but the visualization technique is extremely valuable.

I also use the visualization technique in composing a painting. I start with a theme or special moment, then visualize it in different settings as completed paintings. The final painting won't necessarily duplicate the visualization exactly, but the technique will give you more choices in composing a painting.

A Final Word

Signing the Painting
After you complete a painting and determine that it has turned out well, there are a few more steps to consider. The signature is one of them. You may have seen signatures that were huge, tiny, sloppy, or so fancy that they became the center of interest in the composition.

I suggest a small signature, one that can be read from about four feet away. I was once told by my drawing instructor that the highest compliment an artist could receive was for a viewer to look at a painting then step closer to see who signed it. (Until then, I had been signing my name a bit too large.) Also, make the signature legible. It is the best advertisement you may have.

Matting and Framing
After you have signed your painting, you may want to display it, and this may present more problems. There are many ways to display a watercolor, but only a few are worth noting.

I like a watercolor to be matted and framed under glass. In some cases, glass and a frame molding can look just fine without a mat. But if you do choose a mat, be careful that it does not distract from the painting.

Stick to white and pastel colors that harmonize with your painting, with perhaps a narrow line edging of another color that appears in the painting. Also, keep the mats in good proportion to the work. I usually add a 3″ (7.6 cm) mat to a half-sheet or full-sheet painting. Adding a ¼″ (6 mm) liner won't overdo it, either.

There is quite a bit of controversy regarding the material in a mat. Most artists agree that any portion that touches your watercolor paper must be made of 100% rag. Wood fiber mats and backing apparently have a natural acidity that will eventually destroy your paper. Check with your local framer or art dealer for more information.

Glass
Whether you choose regular or nonglare glass, I recommend that you frame your watercolors under glass. I personally don't care for the nonglare glass, though. True, it cuts glare and reflections of objects in the room, but it also diminishes the amount of light reaching the painting. There is also another problem. Non-glare glass must be in direct contact with a painting or it creates a blurred effect. This is a definite disadvantage in the case of watercolors

because normally a mat must be placed between the painting and the glass to create the air space necessary to prevent moisture from accumulating. If a mat is eliminated in order to make the image sharp, moisture may form and streak the work. If a mat is used, the image will simply be blurred.

Choosing a Frame
I am still in favor of a well-chosen mat with a narrow wood or metal frame around it and the glass. Large moldings, such as those used for oil paintings, are distracting to me. I suggest that you select a neutral color or a molding with a hint of the most frequently used color in your painting. The frame must also be in harmony with the mat. Back the painting with strong, durable backing board over the 100% rag next to the paper.

Framing the Painting
I like to seal the back of my framed paintings with brown paper to prevent moisture from reaching the art. To do this, I glue brown paper to the back of the frame (white glue is fine for this), then moisten it with a sponge and let it dry on the frame. When it dries, it stretches taut and I

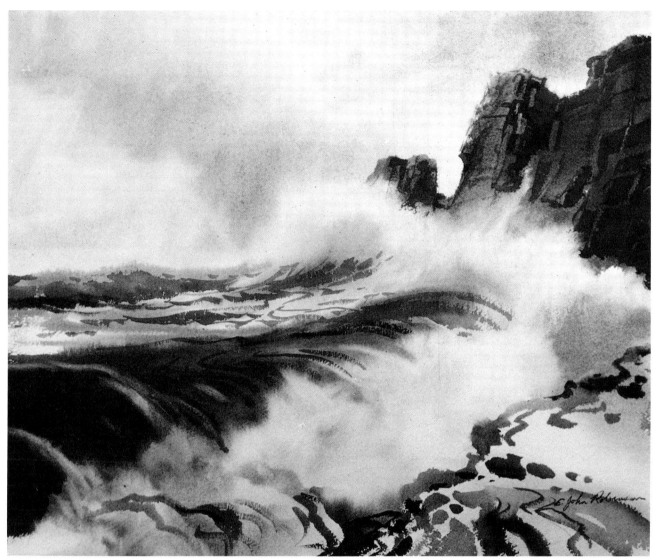

Thunder, 17″ x 21″ (43 x 53 cm), Arches 300-lb rough paper.

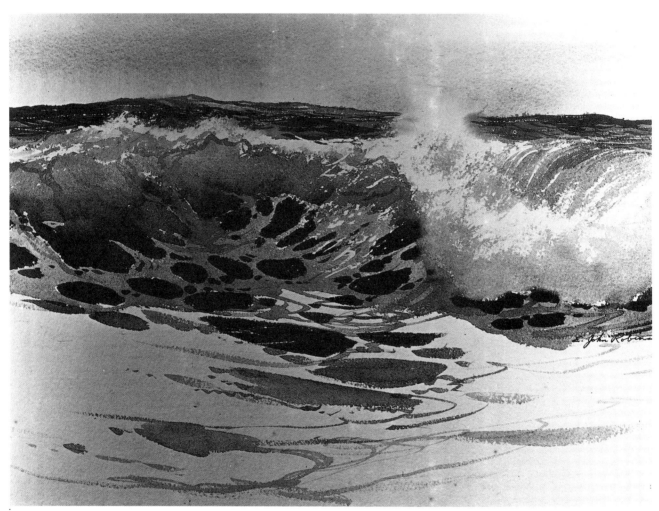

Building High, detail from a 15" x 30" (38 x 76 cm) painting, Arches 300-lb rough paper.

The wave is obviously the subject of this painting, but there would be no interest without the foam patterns and breaker foam. Keep in mind that if the subject is painted too large—about 50 percent of your paper—it is too large to be a focal point. It must then serve as background to a smaller area within it. Therefore, to maintain a focal point, it is necessary to choose a single area of the subject to play up. In this case, I chose the foam patterns in the foreground and let them lead the eye to the wave. They become more interesting where they meet the breaker.

trim the excess paper with a mat knife. I then put two small screw eyes on both sides of the frame, about a third of the way down from the top of the frame and thread sturdy picture wire into them. I leave no slack in the wire since it will stretch a bit on its own as the painting hangs.

Exhibiting Your Work
After you have matted and framed your painting and it looks presentable, the question is just where do you show it? Let me say candidly that I am against showing art in nearly any place other than genuine galleries. I have seen paintings hung in restaurants where the grease caked on the glass. I have seen paintings hung in banks, in butcher shops, in dime stores, and supermarkets. Sure, I know they sell once in a while, but for the most part you are providing someone with free decoration. If all artists pulled their paintings out of those establishments, people just might go to the galleries and purchase some.

It's true that such establishments do present a place for beginners to show work before galleries will accept their art. But you should use them only as an outlet for temporary display of your work. Keep improving the place where your work is displayed and try to find a suitable gallery. Remember, your paintings are your offspring. They deserve the very best.

A word about galleries. I am sorry to say that not all galleries are worthy of your work. Some may have paintings too similar to yours. Some may not show your type of work.

Some are snobbish, and others are downright dishonest.

So check around before you approach a gallery. Check first to see if your work could fit in with their quality and type of art. If you believe your work would fit in, make an appointment. *Never* walk in with an armful of paintings and expect the managers to be delighted to see you. It is not fair to them. They may have customers waiting or be busy. You want their undivided attention anyway, so set up a convenient time for both of you.

If you hang your work in a gallery and you have reached an agreement with them regarding their commission and other business matters, don't allow your paintings to hang for more than four or five months unsold. The gallery may have a policy regarding this also, but if not, paintings that are seen time after time by returning customers show that they are not selling, and therefore may not be worthwhile.

Pricing
One of the most difficult yet most important items for the artist is pricing. Prices are so arbitrary—the whim of the artist or the dealer—that they seem impossible to set realistically. Yet there are some guidelines.

You may not feel confident about your work or you may be anxious to sell and so set your price too low. In either case, you may do yourself a disservice. The public may see through something so obvious. But if you are equally as unrealistic and set your prices too high, the public will also let you know.

If you can avoid underpricing or overpricing your work, you will be in the best position to sell consistently and well. By underpricing, I mean setting a price so ridiculously low in comparison to similar work that it is totally out of line. Yet by overpricing, I mean doing the same thing, but at the other end of the scale. This is one of the few places I recommend making comparisons.

The lesson is simple: The public sets the prices. They will only buy if they think the quality justifies the price that is set. Using this as a yardstick, you may raise your prices or lower them depending upon how fast your paintings are selling.

Attitude
I believe that your attitude is responsible for your success or the lack of it. If you have a realistic pride in your work and confidence that you are truly trying to improve, you will do well. On the other hand, if you lack confidence, or if you are overly critical of your work, I believe that it too will show up in the results.

It is not possible for me to instill confidence in you, but I would like to encourage you to take an honest look at your work and recognize your improvements. Look back to your first attempts and compare them to what you now do. Don't compare your work to that of other artists; that is unrealistic. Only compare your own paintings to each other. Try to improve tomorrow's work against what you did today. The more you do, the better you will do. Experience and a genuine desire to improve is the key to success.

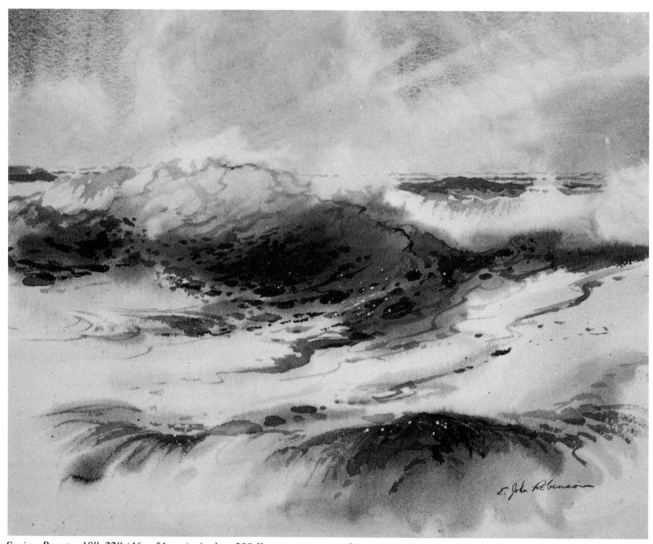

Spring Beauty, 18″x22″ (46 x 51 cm), Arches 300-lb rag paper, rough.

In the spring of the year, the waves are of exceptional beauty. The major storms are over, but the waves are often still quite large. The difference between spring and winter is that in spring there is usually more sunshine and the colors are more brilliant.

In this painting, I portray a large wave about to break. The sunlight comes from behind the wave, making the thin water of the rising wave translucent. This is a composition using dark as the center of interest, with a middle value in the background and light values in the foreground. There is no doubt about the center of interest.

Bibliography

Bascom, Willard. *Waves and Beaches: The Dynamics of the Ocean Surface*. New York: Doubleday, 1964 (paperbound).

Pike, John. *John Pike Paints Watercolors*. New York: Watson-Guptill, 1978.

Robinson, E. John. *Marine Painting in Oil*. New York: Watson-Guptill Publications and London: Pitman Publishing, 1978.

——. *The Seascape Painter's Problem Book*. New York: Watson-Guptill Publications and London: Pitman Publishing, 1976.

——. *Master Class in Seascape Painting*. New York: Watson-Guptill Publications and London: Pitman Publishing, 1980.

Sargent, Walter. *Enjoyment and Use of Color*. New York: Dover, 1923 (paperbound).

Special section on waves in *Oceans Magazine*, No. 5, September/October 1975, pp 10–49 (published by the Oceanic Society, San Francisco, California).

Index

Acadia Desert Island, 78
Action, stopping the, 132
Adjacent colors, 36
Anatomy of a wave, 42
 breaker, 42
 breaker example, 43
 Breaker Foam, 44
 color demonstration, 46–49
 energy orbits, 42
 Foam Patterns, 45
Area of interest
 dark, 28
 light, 26
 middle-value, 27
Attitude, 139

Beach with Creek Outlet, 69
Beach with Driftwood, 70
Beach with Rocks, 69
Beaches, 68 (*see also* Composing a
 beach scene, Oregon Beach)
 color demonstration, 72–73
 elements of a beach, 69
 wet-sand effect, 71
Big Sea, The, 96
Big Sur Country, 59
Big Sur Gold, 113
Breaker, The, 42
Breaker example, 43
Breaker Foam, 44
Breaker foam, painting, 79–80
Brushes, 19
Building a composition, 131
Building High, 138
Burst, The, 51

Cabo San Lucas, Baja, CA, 35
California sunset, demonstration,
 106–113
 color demonstration, 110–13

compositional sketches, 109
 painting glow, 107–8
Cameras, 133
Carmel Surf, 38
Center of interest and lead-ins, 24
Choosing a frame, 139
Clouds, painting basic, 62
Collapsed wave, painting a, 81–82
Color
 basic terminology, 36
 color and mood, 36
 earth, 36
 primary, 36
 secondary, 36
 tint, 36
Color demonstrations, 46–49, 56–59,
 64–67, 72–73, 83–85, 91–95,
 102–5, 111–13, 124–26
Color sketch, 123
Compact travel kit, 18
Complementary colors, 36
Composing a beach scene, 115
 driftwood, 120
 logs, 121
 outlet with ripples, 118
 outlet with rocks, 119
 reflections, 117
 sand texture: wind ripples, 115
 texture: sand bumps, 116
Composition, 22
 areas of the composition, 25
 building a, 131
 center of interest and lead-ins, 24
 dark areas of interest, 28
 light area of interest, 26
 line and value sketches, 30
 middle-value area of interest, 27
 outlines and line sketches, 23
 typical sketches, 32–35
 value, 90, 109, 122

Compositional sketches, 90, 109, 122

Dark area of interest, 28
Detail of the texture, 127
Detail of the wave, 127
Driftwood, 120

Earth colors, 36
Energy Orbits, 42
Exhibiting your work, 139

Finding a subject, 130
 building a composition, 131
 movie camera, 133
 still camera, 133
 stopping the action, 132
 viewfinder, 135
 visualization, 135
Foam burst, painting a, 100–1
Foam patterns, 45
Foamy Surf, 22
Foamy Surf, 41
Framing the painting, 139
Full Force, 14

Glass, 136
Glow, painting, 107–8
Gully Point, 85

Headlands, painting, 54–55

Keanae Point, 105

Lead-ins, 24
Light area of interest, 26
Linear composition, 90, 109, 122
Logs, 121

Matting and framing, 136
Middle-value area of interest, 27

Movie camera, 133

Neutral colors, 36
New England coastline, demonstration, 78
 color demonstration, 83–85
 painting a collapsed wave, 81–82
 painting breaker foam, 79–80

Oregon Beach, 126
Oregon Beach, demonstration, 114–26
 color demonstration, 124–26
 color sketch, 123
 composing a beach scene, 115
 compositional sketches, 122
 detail of the texture, 127
 detail of the wave, 127
Oregon Rocks, 11
Outdoor painting materials, 20
Outlet with ripples, 118
Outlet with rocks, 119

Paintbox, 19
Painting a collapsed wave, 81–82
Painting a foam burst, 100–1
Painting basic clouds, 62
Painting breaker foam, 79–80
Painting glow, 107–8
Painting headlands, 54–55
Painting palm trees, 97
Painting rocks, 52–53
Painting rock spills, 98–99
Painting wave patterns, 87
Paints, 16
Palette, 19
Palm trees, painting, 97
Paper, 16
Patterns, using for direction, 88–89
Peck, James Edgar, 10

Pricing, 139
Primary colors, 36

Quiet Twilight, 106

Rainstorm, 86
Rain to the North, 76
Reflections, 117
Regular outdoor kit, 21
Rising Power, 95
Rock and Headland, Carmel, CA, 33
Rockport, Mass., 32
Rocks and headlands, 50
 color demonstration, 56–59
 example, 50
 painting headlands, 54–55
 painting rocks, 52–53
Rock spills, 98–99

Sand texture: wind ripples, 115
Secondary colors, 36
Seventeen-mile Drive, near Pacific Grove, CA, 34
Shade, 36
Signing the painting, 136
Sketches, 23, 30, 32–35, 90, 109, 122, 123
Skies and clouds, 60
 color demonstration, 64–67
 example, 60
 painting basic clouds, 62–63
"Slick," 71
South Coast, 61
Southern Oregon, 114
Spring Beauty, 140
Still camera, 133
Stopping the action, 132
 movie camera, 133
 still camera, 133

Storm Fury, 37
Storm water, demonstration, 86
 color demonstration, 91–95
 compositional sketches, 90
 painting wave patterns, 87
 using patterns for direction, 88–89
Studio equipment, 17, 19
Swells, 41

Texture
 detail of the, 127
 sand bumps, 116
 wind ripples in sand, 115
Thunder, 137
Tint, 36
"Tooth," 16
Tropical waters, demonstration, 96
 color demonstration, 102–5
 painting a foam burst, 100–1
 painting palm trees, 97
 painting rock spills, 98–99

Using patterns for direction, 88–89

Value composition, 90, 109, 122
Viewfinder, 135
Visualization, 135

Waimea Beach, 75
Wave
 detail of the, 127
 example, 40
 patterns, painting, 87
Wave Study, 12
Wayside Surf, 29
Wet-sand effect, the, 71
Wind ripples, 115
Winter Wave, 128
Winter Waves, 48–9

Edited by Bonnie Silverstein
Designed by Bob Fillie
Graphic production by Hector Campbell
Set in 10-point Times Roman